PICTURING UTOPIA

A BUR OAK ORIGINAL

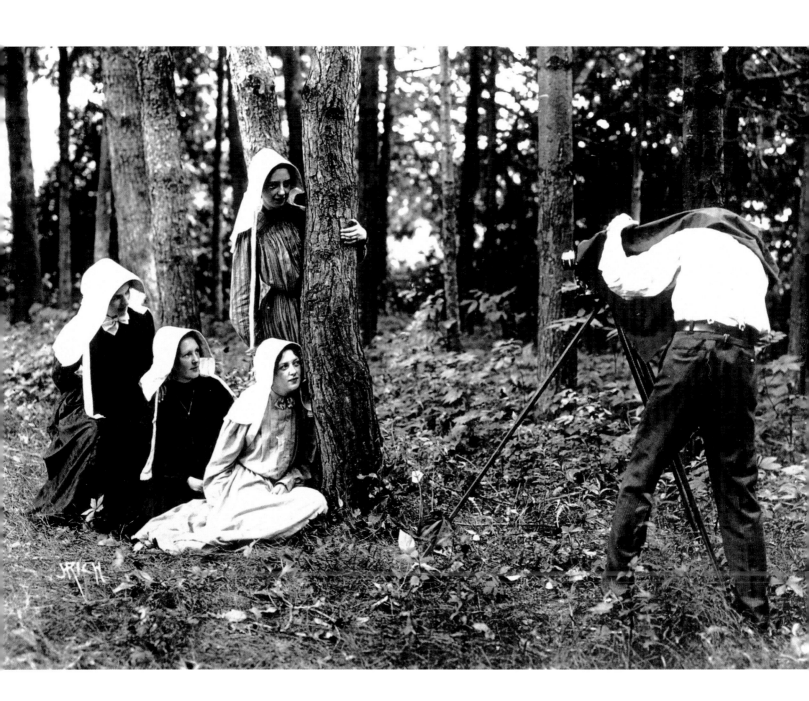

PICTURING UTOPIA

Bertha Shambaugh & the Amana Photographers

ABIGAIL FOERSTNER

UNIVERSITY OF IOWA PRESS IOWA CITY

University of Iowa Press,
Iowa City 52242
Copyright © 2000 by the
University of Iowa Press
All rights reserved
Printed in Singapore
Designed by Richard Hendel
Typeset by Eric M. Brooks
http://www.uiowa.edu/~uipress
No part of this book may be reproduced or
used in any form or by any means, electronic
or mechanical, including photocopying and
recording, without permission in writing from
the publisher. All reasonable steps have been
taken to contact copyright holders of material
used in this book. The publisher would be
pleased to make suitable arrangements with
any whom it has not been possible to reach.

The publication of this book was generously
supported by the University of Iowa Foundation.

Printed on acid-free paper

Library of Congress
Cataloging-in-Publication Data
Foerstner, Abigail, 1949–
Picturing Utopia: Bertha Shambaugh and the Amana
photographers / by Abigail Foerstner.
p. cm.—(Bur oak original)
Includes bibliographical references.
ISBN 0-87745-699-2 (cloth)
1. Documentary photography—Iowa—Amana.
2. Shambaugh, Bertha M. H. (Bertha Maude Horack),
1871–1953. 3. Amana Society—History—Pictorial
works. 4. Amana (Iowa)—History—Pictorial works.
5. Collective settlements—Iowa—Amana—Pictorial
works. I. Title. II. Series.
TR820.5.F64 2000
779'.99777653—dc21 99-047858

Frontispiece
John H. Richmond, known as J. Rich. The Cedar Rapids
photographer set up a second camera to take this self-portrait,
Amana, ca. 1908. Museum of Amana History, gift of
Joan Liffring-Zug Bourret.

00 01 02 03 04 C 5 4 3 2 1

Dedicated to

JOHN, WILLIAM, ELIZABETH, *&* LAURA

that they may cherish their heritage

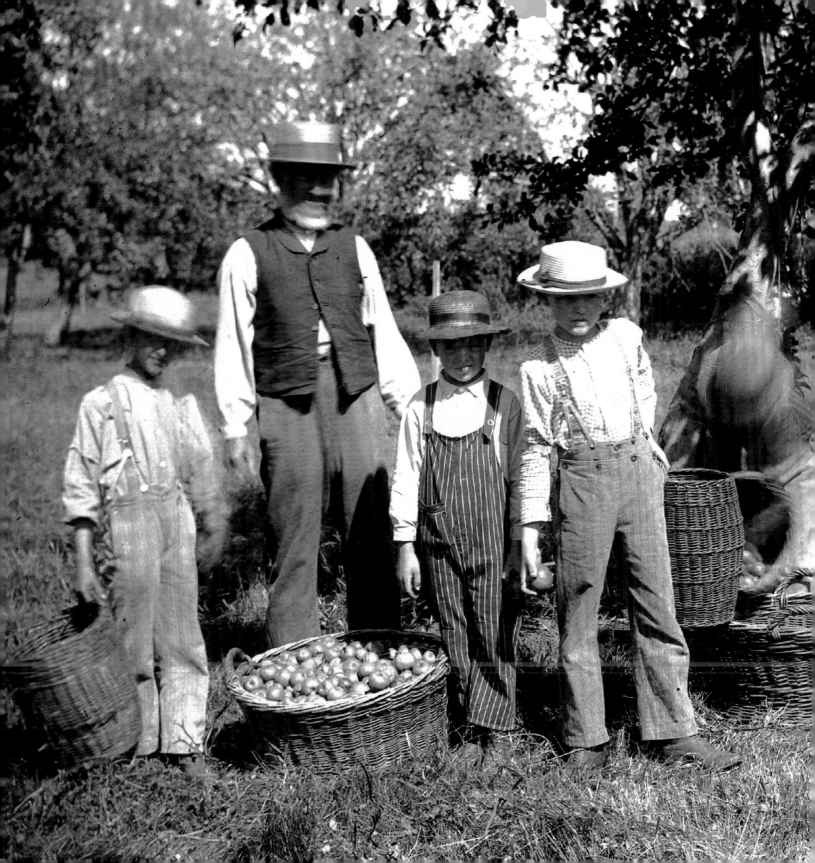

CONTENTS

Preface, ix

Introduction, 1

Bertha Horack Shambaugh: Pioneering Photographer, 5

Bertha and Benjamin Shambaugh: Hosts for a Mecca of Minds, 15

The Amana Experience, 29

Amana Photographers: The Insider's View, 39

 William Foerstner, 42

 Christian Herrmann, 45

 Paul and Rudolph Kellenberger, 48

 F. William Miller, 51

 William F. Noé, 54

 Friedrich Oehl, 56

 Jacob and Henrietta Selzer, 59

 Peter Stuck, 61

Notes, 141

Bibliography, 145

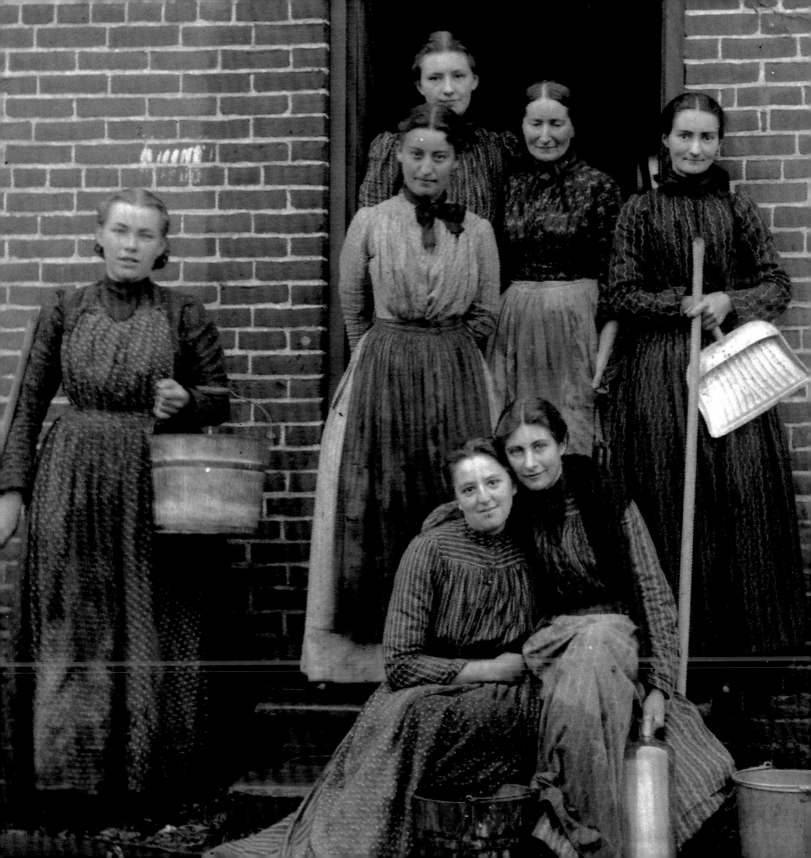

When I was ten years old, I taught myself to knit and thought how surprised my grandmother would be. But the only time I knitted in her presence was late that summer at her funeral. The needles and yarn and comments of the neighbors about my work were comforting as I sat in her rocking chair in her living room in South Amana, Iowa, while mourners filed past the coffin across the hall. Many years of visits after the funeral, I returned as a college student to research a lengthy paper on the Amana Colonies, and I discovered Bertha Horack Shambaugh and her Amana histories for the first time. I took several rolls of pictures for my project and only later realized that Shambaugh had extensively photographed the Amanas, creating a rare documentary of a nineteenth-century utopian religious society and an icon image of a grandmotherly woman and child in her portrait "The Knitting Lesson."

I felt a personal bond to Bertha Shambaugh because of that photograph and because she had written and published books—my idea of the greatest accomplishment anyone could hope to achieve. I pursued a career as a newspaper reporter and later wrote hundreds of articles on photography for the *Chicago Tribune* and many magazines. I soon realized that Shambaugh was a pioneer who deserved recognition in photographic history.

Few women one hundred years ago had undertaken documentary photography projects, and fewer still followed up with written histories of the places they photographed. In addition, Shambaugh brought from the Amanas a clear social mission to tell a world mired in the upheavals of the 1890s about a kinder way of life. But her pioneering social documentary photography is little known outside Iowa. In most cases, her work and the work of other photographers inside the Amanas have been published as historic illustrations without a byline. This book is an attempt to bring these photographers onstage with their photographs and to celebrate the extraordinary number and quality of pictures taken in a community in which photography was officially prohibited.[1]

Bertha Shambaugh cherished the Amanas and won trust easily there. Who could have refused to allow the idealistic young woman to take a few pictures? Who could have guessed she would open the door to others, who would take hundreds more and preserve

seven generations of heritage just as it careened on a collision course with the twentieth century? You can hold up a glass plate negative to the light and peer through the still, silvery image like a magic window to the past.

I started going through glass plate negatives at the Museum of Amana History, where all or part of the archives of several photographers are gathered. Many pictures were not identified by photographer, however, and many negatives were still in family hands, often in homes where the original photographers had lived. Their sons and daughters, their grandchildren and great-grandchildren brought the works out from desk drawers, closet shelves, and attics. Most of the negatives were stacked in boxes in which the original unexposed glass plates had been sold. They carried the product names of Seed, Hammer, or Kodak "dry plates" that came from stores in Cedar Rapids, Iowa City, Chicago, and from mail-order catalogues.

Pharmacist F. William Miller's negatives remained in their original sleeves, on which he had recorded f-stops, exposure times, exact dates, and details of every image recorded. Dr. Christian Herrmann had kept a logbook that recorded similar information about his images. The families had kept old photo manuals, developer recipes, and equipment catalogues. They shared diaries, letters, and memories. A private collection included several of Shambaugh's original glass plates, including "The Knitting Lesson," a negative the size of a small windowpane that was like finding an x-ray of the soul of a community. This piecing together of history from old records and lovely hours of sitting in people's homes and listening to their stories of the past differed very little from Bertha Shambaugh's research methods one hundred years ago. The information age of the Internet and most of the twentieth century fell away like mist. The best knowledge is still held in the human heart.

Inevitably, in a community in which just about everyone is related in some way over the generations, I discovered that one important photographer of the past was my great-uncle, William Foerstner, of High Amana. I was, of course, familiar with the picture of his own wedding procession, snapped by a friend from an upstairs window of the High Amana Church, where he had set up the camera beforehand. And I had a postcard copy of his picture of the South Amana barn fire in 1908. But I had no idea of the extent of his photography. His daughter, Emilie Foerstner Jeck, still lives at the family home, and she took me to her attic, where we looked at hundreds of his negatives stored in Amana baskets. His camera, developing gear, and kerosene lantern for lantern slides were on the

shelves above. Amana and several towns around it came to life in this time machine of early twentieth-century photography.

My father had left the Amanas for good at age eighteen, but obviously it helped that people had known him or my grandparents as I called to set up interviews. Over and over, people told me about the 1959 auction of the contents of my grandmother's house, the year after she died. It was a story with which I was very familiar—I was there. Couches, dressers, tools, washtubs, stools, beds, and rocking chairs were pulled out onto the lawn for public auction, and most things sold for under three dollars. The treasure hunt spirit of emptying the house, the crowd, and the auctioneer with his voice on overdrive were very exciting at first. The objects strewn throughout the yard looked like a storybook version of camping out, and a local newspaper covered the auction. But as the day wore on and the crowd and the precious objects thinned, even a child could feel the permeating sense of loss. We all lived so far away and had space to take so few things home. My father packed up my grandparents' oval-framed wedding picture that hangs in my living room and a dog-eared photo album. The ghostly photographs witnessed the lives of my grandparents and great-grandparents, lived out in that very house with the very furnishings that were sold at auction. The pictures had been snapped by another great-uncle, William Heisterman, on his many visits "out home" after he too had moved from the colonies.

The photographs taken by the Amana photographers that are included in this book differ, however, from pictures in family albums. The Amana photographers documented absolutely everything. They worked with "a compulsion to take pictures, an irresistible need to do it, an imperative that reaches from Eugene Atget to Henri Cartier-Bresson, from amateurs to professionals," as the book *Bystanders* describes the documentary urge.[2] They showed up at train wrecks, car accidents, fires, and floods. They captured people and events all around them and carefully composed pictures of cutting ice from the river, preparing communal meals, and all the other mundane tasks that build into an extraordinary record of activities that are now extinct. Together, the early photographers shot thousands of glass plate negatives, and more than a thousand are known still to survive. The next generation carried on the tradition with film negatives.

An unbroken photographic record of the Amanas begins in 1890 with Shambaugh, continues at the turn of the century with the work of F. William Miller, William Foerstner, Christian Herrmann, Friedrich (Fred) Oehl, Sr., and Charles Ruedy. Several of these

photographers and Jacob and Henrietta Selzer carry the record into the 1920s. Peter Stuck and Rudolph (Rudy) Kellenberger started photographing then too. As the Amana people made a swift transition to mainstream American life with the Great Change in 1932, Rudolph Kellenberger and his brother Paul and William F. Noé were there to document it. At the time of the Change, Amana still resembled the communal society established when the Amana leaders brought the Community of True Inspiration to the United States from Germany nearly one hundred years earlier.

Undiscovered photographers may surface from glass plate collections still to be discovered in uncharted Amana attics. A growing number of images (both glass plates and film negatives) have found their way to the photography archive of the Museum of Amana History. Shambaugh's 1908 portrait in Amana dress—a dress she borrowed from a great-granddaughter of the revered Amana leader Christian Metz—presides over this collection. The devotion to Amana history evident in her books and photographs leaves the impression that she feels at home.

History owes a debt of gratitude to the Amana Colonies photographers who ignored the community's religious scruples that condemned picture taking. They left behind a rare documentary of a nineteenth-century religious utopia in a collection of images that is astounding in its beauty and diversity. They have my heartfelt thanks and all my admiration. When I proposed a book to celebrate their photography and the photographs of Bertha Shambaugh, many others who admired them came forward to help bring to a new generation a timeless story in pictures of human hopes and longings. Many thanks to David Dierks of the University of Iowa Foundation, who gave the immediate impetus for the project as we swapped Shambaugh legends at a university dinner.

Sincere thanks to Lanny Haldy, director of the Museum of Amana History, which is operated by the Amana Heritage Society. Thanks as well to Catherine Guerra, curator of museum collections and a great-granddaughter of Friedrich Oehl, Sr., one of the photographers featured in this book. They answered dozens of questions, located research materials, provided workspace for the author during sixteen research trips, and offered endless encouragement. They also made the museum available as a temporary repository for family photo collections researched for this book.

Special thanks as well to Mary Bennett, special collections coordinator at the State Historical Society of Iowa, Iowa City, for invaluable insights on Bertha and Benjamin

Shambaugh and help in researching their voluminous archives at the historical society and at the University of Iowa Libraries. Bennett generously shared her own research on the Shambaughs, including taped interviews with those who knew them and files of notes gathered over the past twenty years for her own collections, *An Iowa Album: A Photographic History, 1860–1920* and *Iowa Stereographs.*

Both the museum and the historical society made dozens of negatives available for reproduction for this book; dozens more were lent by relatives and friends of the Amana photographers, whom I gratefully wish to thank: Louise Miller DuVal, Peter Hoehnle, Emilie Hoppe, Emilie Foerstner Jeck, Joann Foerstner Meyer, Erma Schanz Kellenberger, Patrick and Kathy Kellenberger, Ruth Herrmann Schmieder, and Clifford Trumpold. Thanks as well to photographer Joan Liffring-Zug Bourret for making her collection of Amana photographs available. These and many other friends and relatives provided first-hand memories, insights, documents, and other information during interviews. These invaluable sources include George Foerstner, Elsie Foerstner, Harold Foerstner, Carl Oehl, Elizabeth Oehl Wetjen, Henriette Roemig, Arthur Selzer, Carl Bendorf, Marie Noe Larew, Barbara Selzer Yambura, and Barbara Selzer Hoehnle.

A warm thank you to Paul Kellenberger, who is among the photographers featured in this book, for providing hours of historical perspective and background in interviews. Thanks also to Stow Persons of the University of Iowa for his insights on university life and the Shambaugh's world at the close of the nineteenth century. All the oral histories quoted in this book result from more than twenty-five interviews with the author unless otherwise noted.

Technology assisted where time had taken its toll on some of the negatives. The effects of even slightly insufficient washing or fixing years ago, compounded by exposure to heat and humidity since, had left some glass plate emulsions faded, spotted, or peeling. Polaroid Corporation, through its Applications Group, lent a 600 LE scanner with a transparency adapter and other equipment to safely scan negatives using Adobe Photoshop, so that the images could be restored to match the tonal quality of vintage prints whenever they were available. More than 130 images have been archived on two recordable compact discs. Helix Camera and Video in Chicago converted the digital files back to photographic silver prints using a dry silver process invented by Polaroid and a Fuji PG 3000 digital printer.

The University of Iowa made this project possible in countless ways. Many thanks to the University of Iowa Foundation and to the special collections staff at the University of Iowa Libraries in particular for their help. Holly Carver, my editor at the University of Iowa Press, gave unremitting encouragement and vision in the pursuit of an art book on Amana photography that would celebrate the photographers themselves for the first time. As we sat outside the press on a sun-spangled day going through images for the book, we felt sure Bertha Shambaugh was urging us on just as she had urged on so many projects to proclaim the visionary success story of the Amana Colonies.

Thanks beyond measure to my family for the most valuable gift of all toward this book—the gift of time. My aunt Elsie Foerstner, my husband, Arthur Caudy, and my children pulled together to make possible the two years of research and writing and the monthly trips to Iowa needed for this project.

Picturing Utopia

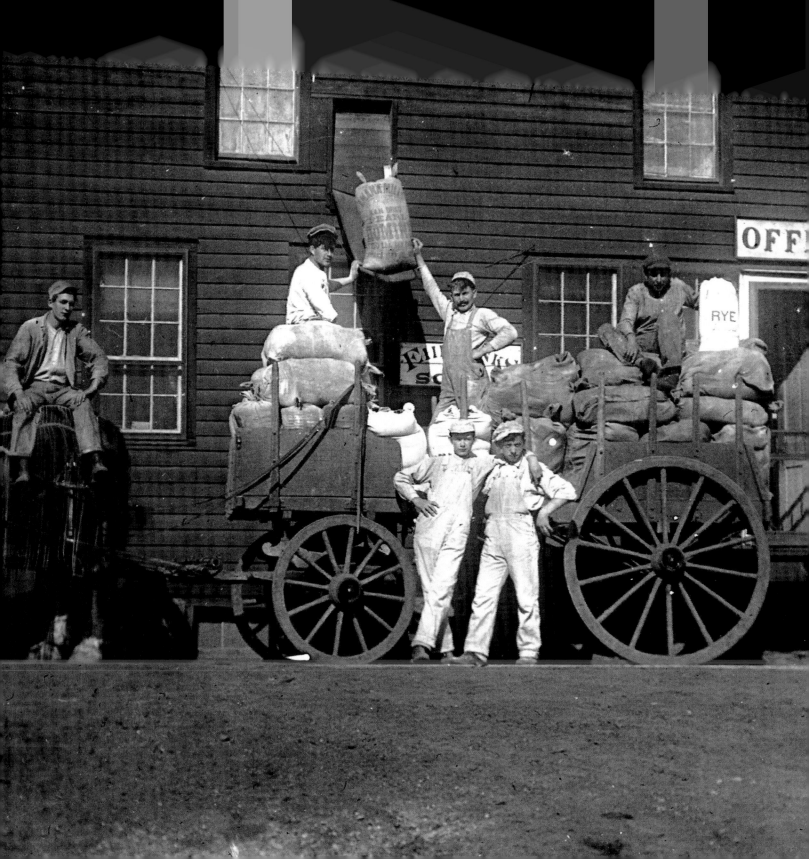

In the summer of 1890, Bertha Horack, a nineteen-year-old University of Iowa student, set out to photograph the Amana Colonies, the utopian religious community twenty miles northwest that she had visited several times before on summer visits with her family. She traveled by train with her beloved mother, Katherine Mosnat Horack, and presented the very picture of Victorian propriety. Yet everything else about the bright and ever curious Horack marked her as a woman ahead of her time. She was among the earliest social documentary photographers, mastering the behemoth view camera that had to be loaded with individual glass plate negatives measuring five-by-eight inches each. She found a market for her photographs and drawings by pairing them with freelance articles she wrote for illustrated magazines. She also published the most definitive history of the Amana Society in her 1908 book, *Amana: The Community of True Inspiration*.

Bertha Horack married political scientist Benjamin Shambaugh, who joined with other maverick young professors to reshape the University of Iowa into its modern academic departments. Celebrities, family, and homesick graduate students gathered at the Shambaughs' home, a mecca for Iowa City intellectual life. Benjamin Shambaugh's guest lecture series brought many famous visitors to the house. The couple hosted Amelia Earhart, Thornton Wilder, Hamlin Garland, Jane Addams, Walter Lippmann, the Grand Duke Alexander of Russia, and explorer Roald Amundsen, the first to reach the South Pole.

Although their social circle may suggest a distant era, the Shambaughs confronted a world that mirrors our own in significant ways. Old social structures seemed to be crumbling as a surge of technology introduced telephones, electricity, and automobiles to everyday life. Advertisements for new drugs, building contractors, and banks on the front pages of the *Iowa City Daily Republican* flanked gloomy reports about local murders and farm foreclosures and gossipy features on the escapades of foreign royalty. Wage riots, lynchings, and worker strikes captured the news, and the threat of worldwide depression loomed even while the world celebrated a new era of progress with the World's Columbian Exposition in Chicago in 1893. The sense of crisis reflected deeper uncertainties as the

theory of evolution challenged the biblical account of creation, and the theory of relativity soon challenged the certainties of Newtonian space and time.

By comparison, Amana reflected a just society in which everyone sacrificed personal gain for cooperative prosperity and spiritual growth. Bertha Shambaugh saw clearly—as many observers did not—that the Amanas had developed a communal society to free people for religious devotion rather than as a political end. In their mystical relationship to God, however, the Community of True Inspiration of Amana had carved out a bit of heaven on earth. Shambaugh's interest in scientific documentation and her social ideals, led her to photograph the colonies.

Many before Bertha Shambaugh had documented wars, natural wonders, and exotic cultures. In the late 1890s, with new rotary press techniques, newspapers and illustrated magazines began to print photographs directly rather than from woodcuts or engravings copied from the images. Before long pictorial photographers, led by Alfred Stieglitz and the Photo-Secessionists in New York, would take photography into the realm of art with lyrical images that resembled paintings. Social documentary photography was just emerging in the 1890s, a product of rampant urban poverty, easier-to-operate cameras, and mass-market publications. Other photographers—most notably Jacob Riis, photographing in the immigrant slums of New York City—used the camera to crusade against social ills.

In undertaking the Amana project, Shambaugh fit into the new breed of photographers with a social message. They included yellow journalists and crusaders who photographed to expose the world's wrongs, and documentary photographers and social scientists who sought to survey times and cultures on the brink of extinction. Shambaugh took the social documentary approach to a place that had captured her idealistic imagination ever since her girlhood stays there. She trained her camera on Amana as a model society "with a more rational and ideal life" than could be found in the towns outside it.

Shambaugh was the first "outsider" and one of the earliest photographers allowed to document the Amanas. It was a time, according to Shambaugh, "when there was still an effort to maintain Amana's circle of seclusion."[1] Community elders ordinarily upheld the inspired testimony that had placed photography among the worldly vanities to be shunned. Because other communal societies also discouraged photography, hers is a rare and possibly unique documentary of nineteenth-century religious utopias. Equally important, she

opened the door for photography in the Amanas by both amateurs within the colonies and professionals from nearby towns. Within a few years of her project, several residents took up cameras and preserved an "insider" view of their communities. Like Shambaugh, they chose complicated, but optically peerless, view cameras loaded with glass plates instead of the new amateur box cameras loaded with film. The beautiful, hand-tooled view cameras allowed them to control exposure settings and came with magnificent lenses that insured sharp focus on the large-format negatives. Glass plates continued to be readily available through camera stores, Sears and Montgomery Ward catalogues, and other mail-order outlets. The catalogues advertised the view cameras and glass negatives as the premium choice for serious photographers long after film negatives had gained the edge in the snapshot market.

Though they came from a seemingly homogeneous society, the Amana photographers took pictures of remarkable diversity. F. William Miller wrapped images in the charmed circle of family life yet went out to cover disasters with the instincts of a photojournalist. Christian Herrmann documented human frailty, hardship, and endurance with poetic compassion. William F. Noé brought an encyclopedic documentary approach to the entire Amana experience. Rudolph Kellenberger found powerful graphic images in everyday farm scenes. Paul Kellenberger photographed the rapidly changing social forms after the Change that brought Boy Scout troops, Maifests (May Day celebrations that predated the Octoberfests), and even sunbathing on the Iowa River. But he also returned to the interiors of old Amana churches and buildings, where he captured visually ethereal links to the past.

William Foerstner, ever the businessman, took classic shots that could have been advertisements—the bicycle is shown eclipsing the horse and buggy and the Brunswick sales trucks bringing tires for the burgeoning automobile age. Fun-loving Friedrich Oehl photographed the itinerant workers of the towns, lighthearted entertainments, and posed his family in "you are there" disaster scenes such as the aftermath of a flood. Peter Stuck carefully positioned flowers for sculptural, elegant botanical studies. Jacob Selzer choreographed and photographed hilarious tableaux even though he was gravely ill. After his death, Henrietta Selzer made pastoral portraits of their children in every idyllic Amana setting she could find.

These photographers captured the Amanas as its isolation and religious fervor were

dwindling. When the colonies reorganized in 1932, however, they were among the longest lasting and most successful of more than one hundred utopias that operated on the basis of religious communalism across nineteenth-century America. Luckily, the work of so many photographers in so small a community insured preservation of a vanishing way of life in unprecedented detail.

Bertha Horack Shambaugh *Pioneering Photographer*

Bertha Maude Horack was born into the tightly knit Czech community of Belle Plaine, Iowa, in 1871. The circle of relatives and friends that surrounded her father, Frank J. Horack, and her mother, Katherine Mosnat Horack, would foster a sense of roots and tradition. Belle Plaine and the nearby Amana Colonies drew her back "home," even though she moved with her family to Iowa City when she was about eight years old and lived there for the rest of her life. The move enabled Frank Horack to study law at the University of Iowa and establish a law practice. The family settled into a spacious house at 120 North Dodge Street that became the subject of many of Horack's early photographs. Once again, Katherine Horack sought out the Czech community, and many of her new friends brought their legal needs to her husband because they trusted her as a translator and confidante.

The university gave an intellectual and cultural backdrop to life in Iowa City and reinforced progressive ideas about educating young women and giving them the right to vote. The Horacks encouraged the academic and independent intellectual pursuits of their only daughter and eldest child. By the time she entered her teens, Bertha Horack had encountered three significant forces that set her on the course of becoming a documentary photographer and historian: the Unitarian Church, the Agassiz Association (a science club for youth), and the poet Ralph Waldo Emerson. The Unitarian Church held liberal social views and a belief in the essential goodness of all human beings. The church validated individual religious experience, a tradition it shared with the more conservative Inspirationists of the Amana Church. The Unitarians reflected perfectly the optimistic faith in the progress of the human race through knowledge. The hope of the era was that knowledge could apply scientific solutions to social problems, and the Unitarians brought in cultural leaders who gave what Benjamin Shambaugh referred to as "lecture-sermons," many complete with lantern slides.[1] Poet and popular philosopher Ralph Waldo Emerson, who had

been a Unitarian minister early in his career, ranked among the church's most renowned guests in Iowa City. Emerson visited Iowa for the last time in 1871, the year Bertha Shambaugh was born. It was his friend Louis Agassiz, founder of the Agassiz Association, who popularized Emerson's transcendental philosophy for a new generation in his popular science club for youth.

"Yon ridge of purple landscape / Yon sky between the walls / Hold all the hidden wonders / In scanty intervals," wrote Emerson in his poem "The World-Soul." The poem embodied the radiant ideal of intertwined natural and spiritual forces in the universe, a compelling belief that allowed Victorian faith in both religious mysteries and scientific progress. "Bertha kept a picture of Emerson above her desk until the day she died," according to Mary Bennett, special collections coordinator of the State Historical Society of Iowa.

Horack joined the science-oriented Agassiz Association at age eleven. The organization impressed upon its members that each human being had a responsibility to use his or her intellect to make the world a better place and promoted learning in the natural sciences through challenging programs. In preparation for its fourth annual convention in Iowa City, the association asked members to research answers for one hundred discussion questions posed in a pamphlet. Questions ranged from the migration habits of spiders to details about the moon's orbit around the earth. A lengthy handwritten paper Horack wrote for presentation at an association meeting discusses the evolution of birds from dinosaurs. Several shaded pencil drawings illustrate the dinosaurs that most clearly support the link.[2]

Horack's 1880s scrapbooks poignantly fuse the romanticism of a young girl with her keen interest in history, botany, and artistic design. Part way through, the scrapbook departs from the collection of brightly filigreed valentines and incorporates actual examples of various leaves and species of flowers pasted in position, including a present made to her of a leaf from an elm tree at George Washington's Mount Vernon estate. Her notation reads: "The father of his country took command of the little band of patriots who won glory for themselves and liberty for their posterity."[3]

For her high school graduation present, her parents bought a view camera, a trendy present for a young woman in the 1880s, but one well suited to Horack's artistic and scientific interests. She continually sketched flowers and animals as well as whimsical scenes for her short stories, although she was critical of her drawing abilities and lamented on the

back of one sketch that perhaps formal training could have improved her skill. Photography allowed her to document the world precisely. Even with innovations, however, the craft relied on unwieldy equipment, glass negatives the size of small windowpanes, and caustic chemicals.

Photography was half a century old in 1889, when Horack received her camera, and it had already undergone sweeping changes. Daguerreotypes, the first viable photographs, delivered one-of-a-kind images in luminous detail, captured directly on metallic plates; thus, there was no negative from which to make prints. Positive negative photography, destined to become the mainstay of the media, looked muddy compared to the hauntingly lifelike daguerreotypes of the 1840s and early 1850s. Exposure times of several minutes required the subjects to place their heads in braces so that no motion would blur their portraits. The expressions that often resulted appeared wooden if not downright tortured.

"Wet plates" swept the field of photography in the 1850s. Negatives were prepared by coating glass plates in the dark with a light-sensitive mixture of potassium, collodian, and acidified silver nitrate. The negative had to be loaded into the camera, exposed, and developed while still wet. Despite the cumbersome procedure, wet plates produced sharp negatives with rich tones and reduced exposure time. Most important, they meant any number of prints could be made from the negative. William Henry Jackson, who photographed the West in the 1860s and 1870s, and Mathew Brady, who photographed the Civil War, traveled with makeshift darkrooms fitted into wagons as they traversed mountains and battlefields with their wet plates.

In the early 1880s, dry plate negatives allowed photography companies such as Eastman Kodak to market ready-to-use glass plates with the dry emulsion already coated on. By the year Bertha Horack started taking pictures, photography was on the threshold of an era that would introduce snapshot cameras loaded with film negatives and increase the use of photo reproduction in the popular press. Eastman Kodak company introduced its first box camera loaded with a hundred film negatives in 1888. Customers sent the whole camera back to Kodak, still loaded with the film, and Kodak processed the pictures and returned the camera with another roll of film. But for the next twenty-five years, glass plate negatives remained the choice of "serious" amateurs and pros. Catalogues offered boxes of a dozen negatives in sizes as large as eight by ten inches, and manufacturers such as Kodak made them in much larger specialty sizes as well. Drugstores and local photogra-

phy studios sold photo supplies, including the glass plates. Shambaugh ordered glass plate negatives and a variety of other photo supplies from T. W. Townsend, who owned Townsend's Photo Studio in Iowa City.[4]

The ready-to-use glass plate negatives required exposure times of less than a second outdoors as compared to several seconds for the slower wet plate emulsions. But the hobby still required an alchemy of light, composition, and corrosive chemistry to obtain favorable results, and the small corps of new amateurs relied on manuals and trial and error to learn their craft.

Photographers focused the camera by moving the accordion-shaped bellows in and out and calculated the f-stop and exposure time they would need by referring to a manual or a light meter. They would open the back of the camera and focus their image through the ground glass. Ovals were often etched into the ground glass so the photographer could compose the shot for the final framed portrait. The image appeared upside down, and the photographer focused it under a dark cloth because background light severely reduced the visibility of the image coming through the camera. With composition and focus set, the photographer replaced the back of the camera with a completely sealed film holder. Once the light-tight container was in place, a thin wooden panel of the holder was removed so that the film plate could be exposed to light when the photographer tripped the shutter. The shutter release was often a handheld rubber bulb. After the shot, photographers replaced the panel of the film holder that protected the negative from light until it could be developed in a home darkroom.

With large-format negatives measuring eight by ten or five by seven inches, prints could be made by simply laying the negative on a sheet of photo-sensitized paper, exposing it to the sunlight, and then developing the print. These contact prints were the standard for the times. The intense light source used in enlargers would have been nearly impossible to achieve in the era before widespread use of electricity.

Horack mastered this complicated procedure, using five-by-eight-inch negatives loaded in a camera permanently set on a tripod. Her uncle J. J. Mosnat, an Iowa state senator, and her cousin H. Roy Mosnat were already taking photographs. H. Roy Mosnat photographed at the Meskwaki settlement near Amana. The Native American Meskwaki maintained their traditional culture on several thousand acres of land that they bought as a tribe rather than accept exile to a reservation farther west. His 1894 Amana picture of a

knitting lesson, taken at a greater distance and in harsher light than Horack's far more poetic image, suggests that Mosnat and his cousin occasionally photographed together on their separate cameras.

Formal studio portraits remained popular, but the innovation of dry plate negatives established a growing corps of amateur photographers who would bring a candid, casual air to photography. As leisure time activities grew in popularity for the affluent, urban middle class, catalogues and magazines promoted photography as a hobby for men and women. Photographing the ideal house and family became an extension of keeping the perfect house and family. Women's magazines such as the *Ladies Home Journal*, as well as science magazines such as *Popular Mechanics*, ran articles on amateur photography.

But learning photography was often a matter of trial and error. Horack's earliest negatives show her addressing and conquering problems of light and composition. Sunlight pouring through the windows of the family living room delivered a burnt-out halation effect on a picture exposed for the interior of the room. Another try at the shot balanced the exterior light into a soft glow filtering through sheer curtains. Interior shots of houses that celebrated prosperity and good taste were fashionable subjects for Victorian amateurs, but Horack quickly outdistanced the typical amateur in her realization of the importance of perspective in photography. She adopted the more sophisticated vantage point of photographing rooms through open doorways, giving the viewer a three-dimensional impression of walking through the house. Former University of Iowa journalism professor Karin Becker Ohrn writes that Bertha Horack Shambaugh's "photographs have a depth that is not characteristic of family photographs. Similarly, her sense of balance does not require bilateral symmetry so common throughout other collections. Rather than centering the most prominent element in the photograph, [she] often arranged the composition so that the heaviest element, usually a person or beautiful chair, is to one side."[5]

Bertha Horack extensively photographed her family, following a tradition glorified by women photographers. But she, like Julia Margaret Cameron in London, approached photography with a professional and artistic intent. Cameron photographed her charmed social circle, which included William Wadsworth Longfellow, Alfred Lord Tennyson, and astronomer Sir John Herschel in the 1860s, and sold art prints, moving beyond the endeavors of the "lady amateurs" of her day. But some of Cameron's strongest portraits cast her own daughters and women friends in the roles of goddesses or Biblical heroines who

radiate both sensuality and a mystical sense of inner light. The vines of an arbor seem to be growing from her daughter's hair in one ethereal portrait that suggests that photography can touch straight through to the soul.

Horack's best family pictures kindle this same emotional appeal. She photographed Katherine Horack posed in the kingdom of her garden like Mother Earth and turned the camera on herself in expressive self-portraits. In one, she faces an oval dresser mirror so the full regalia of her hat, dress, and demeanor are visible from both front and back. The picture speaks clearly of hopes, dreams, and a happy confidence in her future, and leaves no doubt that Horack intended to be noticed and to create an identity in her own right. Her self-portraits invite the viewer to see her as she sees herself in the privacy of her own room, a daring setting for a prim young woman in Victorian times. Sometimes she would hop in the pictures just before clicking the shutter, as was the case in a photograph of her Pi Beta Phi sorority sisters seated in a boat. In general, Horack tended to pull back from her subjects to show the larger environment, often placing people at the sidelines of an image, as is the case in several romantic garden portraits.

Horack's photographs of her brothers and father hunting, fishing, and camping also express a romantic view of nature and wilderness. Yet the raw-edged shot of her brother displaying a taxidermy specimen of a dead bird goes beyond the sentimental portrayal of a successful hunt. It conveys a straight documentary aesthetic that Horack quickly carried into other subjects. She took photography seriously, stamping her photographs with her name, just as the pros did.

Technical requirements alone narrowed the gap between amateur and professional. The growth of photography as both a highly skilled craft and a hobby involved not just taking pictures but processing and printing them as well. Devoted hobbyists had to have a darkroom at home—the local drugstore did not process glass plates. And many amateurs would drape a corner of the house for an impromptu studio setting to accommodate friends and neighbors. Women as well as men made a living taking pictures; while few professions other than teaching welcomed women in the nineteenth century, they became professional photographers from the inception of the medium.

Sustained documentary projects, however, were beyond the interest of most amateurs and offered little chance to make money for the studio pros. This was the kind of project that most clearly set Horack apart from other amateurs. Her documentary projects were an

outgrowth of her scientific interest in observation and her artistic interest in the wonder and beauty of simple things around her. She began photographing Iowa City soon after she received her camera, documenting dams, bridges, churches, and schools. To take a series of quaint snapshots of her hometown would have been predictable enough and was common practice for pros, who photographed important buildings and spectacular events in various communities for their brisk business in stereo cards. But Horack sustained the project and turned as well to the more intensive photo documentation of the Amana Colonies.

Bertha Horack had few role models—male or female— as she began her social documentary photography project of the Amanas during her annual summer stays in the community. This new brand of photography both reflected and fueled a wave of social and labor reforms and became a vehicle for women to explore beyond the home. Some documentary photographers adopted the methods of Jacob Riis, the *New York Daily Herald* journalist who barged unannounced into squalid tenement flats in the middle of the night with flash powder blazing. Miranda Hofelt, a lecturer at the Art Institute of Chicago, describes the effect: "You're nursing your child and this man comes in. You can imagine how you would react. It gives these people this kind of dazed look."[6] Yet the *Herald* trumpeted the building code reforms won by Riis's crusading photographs. Victorian American Alice Austen gives a distinctly contrasting view of the immigrant experience. A single woman of independent wealth, she ventured from her Statton Island estate to photograph immigrants on the lower east side of New York. According to Hofert, "the camera allowed her to do this," lending her respectability in a neighborhood where well-bred women did not walk. Austen's portrait of a little girl selling newspapers and other scenes conveyed honest hard work and dreams of a better life.[7]

In Maine, Emma Sewell documented changes in the American landscape caused by industrialization. In California, Olive May Percival photographed Chinese immigrants. In Canada, Edith S. Watson photographed Cape Breton islanders and took a few pictures of the Mennonites in the 1920s. Many women documented their own communities.[8] In Iowa, as elsewhere in the country, Mary Jane Chapman Fawcett and Effie Seward photographed rural life and small towns in the early twentieth century. For Fawcett, as for many women, documentary projects ended when she married and began to rear the first of her eleven children.[9]

Horack brought to the documentary of the Amanas her warm regard for her subjects,

her mother's example of unbroken ties to tradition, and her own beliefs about working to make the world a better place. She brought to the photographs the faith of the progressive era that knowledge could scientifically resolve social problems and the ideals of Emerson and the Unitarian church that a supreme order of the universe emanated from life itself. On every level, Amana symbolized the most binding ties of her life and the profound hope of her times in human progress. The Amanas were an example of a better world that had freed itself from both the excesses and materialism of the wealthy in the Gilded Age and the hard times and labor strikes of the poor. The 1890s depression, strikes, suffragettes, and urban squalor clashed with revered ideals of the past.

Horack consciously documented almost every facet of the community as it was rapidly losing the isolation that had been critical to its survival. The trains brought hundreds of tourists to the colonies. On one Sunday in 1901, the *Cedar Rapids Gazette* reported that 700 visitors descended on Amana, a town of 530.[10] Her pictures preserve old Amana just as it was before momentous technological and social changes brought rapid-fire modernization during the 1930s.

In "The Knitting Lesson," Bertha Horack Shambaugh's best-known photograph of the Amanas, an older woman affectionately holds a little girl's hands and teaches her to knit. They sit in a garden on a wooden bench in this epiphany of childhood and serenity. The picture has appeared in countless publications, including the cover of the 1988 reprint of Shambaugh's 1908 history, *Amana: The Community of True Inspiration*. But the picture was cropped to her specifications on a contact print made from her original negative, which is in a private collection in the Amanas. The full-frame five-by-eight-inch negative shows another woman and pupil sitting alongside them. The children learned to knit as part of the elementary school curriculum. Although the teachers in all the village schools were men, the knitting instructors were older women. These women also operated a preschool, or "Kinderschule," in each village to free young mothers for work preparing meals in the community kitchen.

Horack's many pictures of Amana children captured them in a variety of activities, ranging from knitting practice to duties such as gathering apples. Despite the novelty of the camera, the children dutifully posed and pretended not to notice the photographer. She presumably told them to hold very still, because any movement (such as the movement of a hand visible in "The Knitting Lesson") caused a blur in the photograph.

Horack used a range of photographic techniques for her project, including lyrical still lifes, posed portraits of families and individuals, and candids of work in the fields and kitchens. In the candids in particular, she ignored the romantic edicts of an era that preferred pretty or quaint pictures of a "foreign" culture. Rather than idealizing a utopian society, she captured the pulse of day-to-day labor and the everyday clutter that accompanies labor. Although she adopted a straight documentary format, the limits of nineteenth-century photography dictated some of her approaches. She photographed indoor close-ups of church benches, baskets, kitchenware, and woolen mill machinery. Interior shots easily required ten seconds or more to shoot, making it impractical to pose people in the scenes. The emptiness created some of her most powerful compositions, though there were failures too, such as her attempts to photograph the interiors of the woolen mills.

Horack also took several panoramas that show the Iowa River and the Mill Race, the six-mile channel excavated in Amana in the 1860s to power the woolen mills, flour mills, and other industries. She photographed the vast expanses of land surrounding the compact towns where all the architecture matched. Some of the photographs stand best alone as striking compositions, but the entire body of work that builds into a composite history is more important than any single image.

Although Horack made many of the Amana pictures during summer stays from 1890 to 1896, the year before she married, she continued to take photographs later. One portrait of F. William Miller in his pharmacy in Amana would have to have been taken after 1900, when Miller graduated from the pharmacy school at the University of Iowa. Other "outsiders," such as commercial photographer J. Rich of Cedar Rapids, also began photographing the Amanas in the early twentieth century.

Bertha Horack Shambaugh's photography project had profound impact on the Amanas and the course of her own life. It gave photography a foothold in a community where it was discouraged and guaranteed a continuing documentary as insiders began surreptitiously to take pictures of their own. Equally important, Shambaugh provided Amana with a respected historian associated with the University of Iowa and the State Historical Society. She wrote countless articles and two books about Amana history, and newspapers and radio stations sought her out as an expert source as well. She brought her own steadfast support of the colonies to these interviews throughout her life.

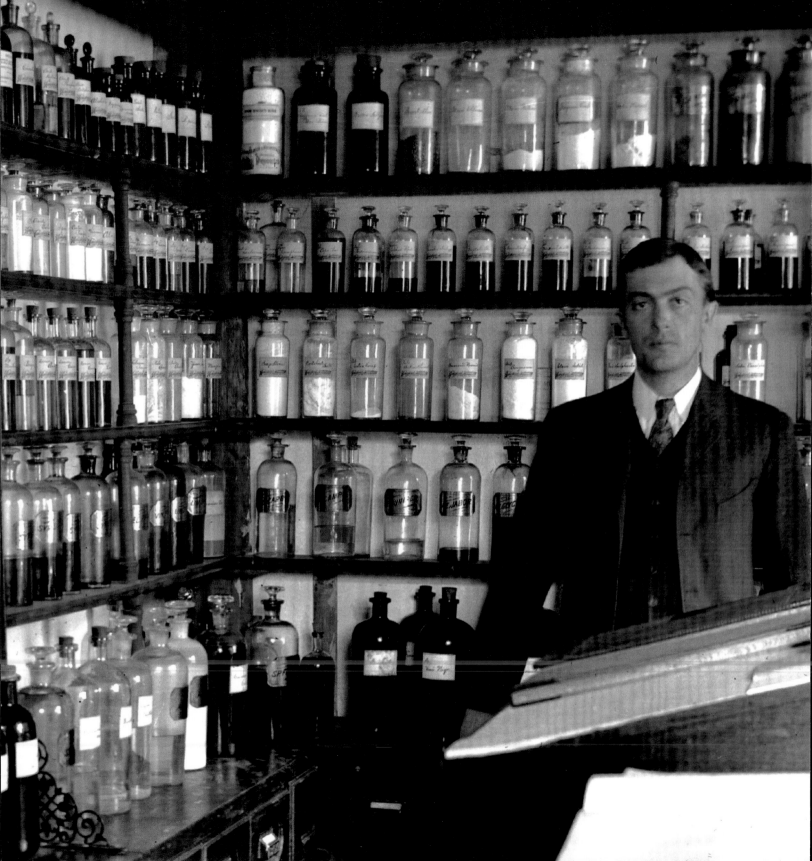

Bertha and Benjamin Shambaugh *Hosts for a Mecca of Minds*

When Bertha Horack started documenting the Amanas, she already had drive, talent, and ambition. But in an era when educated women were expected to be mostly decorative, the support of dashing fellow student Benjamin Shambaugh helped sustain her determination to write history and publish it with her photographs. Bertha Horack and Benjamin Shambaugh met at the University of Iowa when they were both students. She belonged to the Erodelphian Society for women and he to the Zetagathian Society for men, two of four university literary clubs that dominated social life before the heyday of sororities and fraternities. Years after the societies had disappeared, Bertha still described herself as the "Erodelphian whom (Benjamin) as a sophomore invited to a Zetagathian 'Banquet' in 1891."[1]

Horack documented their relationship in numerous photographs: Benjamin formally posed on a bridge, Benjamin in a row boat, Benjamin clowning with her and their friends on the day after his graduation in 1892, and Benjamin perched atop a gazebo reaching for a cluster of bittersweet. The unabashed romanticism of the photographs speaks clearly of Bertha's hopes for their future. Unlike many women of her era, she shared the intellectual pursuits of her future husband and championed them from the start. Horack and her mother attended Benjamin's first public lecture, the 1893 presentation of his master's thesis on the history of Iowa City.

The thesis launched a prestigious career that earned him a reputation as the "father" of Iowa history; but his crusade to popularize history in general had national ramifications as well. He easily blended scholarship and a conversational style geared to general audiences in his lectures and articles. One colleague called him a "practical idealist" with a gift for "converting what appeared to be bare inaccessible hopes with jewels of reality."[2] Another called him a "creative anarchist"[3] who upended the stale traditions of nineteenth-

century college education. History could be a force of action, he believed. History could anchor the democratic vision of an informed electorate deciding its own destiny.

Shambaugh was the grandson of Revolutionary War patriots and the son of pioneers John and Eve Anna Shambaugh, who homesteaded on a 120-acre farm in Iowa when the state was still at the edge of the western frontier. He grew up in the farmhouse his parents built themselves. In a biographical sketch written after his death, Bertha Shambaugh described him as a "sensitive youth with a deeply spiritual nature" who left the homestead at fifteen to attend the Iowa City Academy, a college preparatory school, and then the University of Iowa.[4] After earning his master's degree in 1893, he left Iowa to take his Ph.D. at the University of Pennsylvania and then to study in Germany.

Although Bertha certainly would have seen him on periodic visits home from Pennsylvania, she was determined, according to Mary Bennett, to "strike out on her own" and make a name for herself in his absence. She completed the requirements for a teaching certificate, though she never graduated from the university, and began teaching science at the Iowa City High School. She also started to write for magazines. Her first success was an article on the Amanas published in the *Midland Monthly* in 1896 as the winning entry in its ninth quarterly competition for an original descriptive paper written by an amateur.

The *Midland*, published in Des Moines, was one of dozens of illustrated magazines that accompanied articles with drawings or woodcut engravings. The artwork was often hand-copied from a photograph, and popular national publications such as *Century Magazine* boycotted the new "cheap" rotary-press techniques that could print photographs by the mid-1890s.[5] But the *Midland* did adopt the printing innovations, which enabled Horack to illustrate her article with several of her most poetic pictures of the Amanas. Her selection included children playing under a grape arbor, quaint portraits radiating dignity, and a kitchen still life in which the play of light underscores the order and serenity surrounding even mundane chores. In her article, Horack mentions a towel that hangs from a nook in the kitchen scene, barely noticeable: "During my visit at the colony last summer I took a picture of the hotel kitchen. When I returned this year, the housekeeper confided to me her chagrin on finding that the towel was not clean at the time the picture was taken, explaining just how it happened that it wasn't changed at the proper time. I had not noticed the presence of the towel at all, but to her it was the most conspicuous object in the pic-

ture. I tried to convince her that the spots she saw were only shadows but I am afraid I did not succeed."[6]

Horack had a sure instinct for writing history as good storytelling. Her descriptions were almost as photographic as her pictures, and she drove home her points with powerful anecdotes: "As we sat in the arbor, one unfortunate little girl whose mind was evidently a blank came bouncing in. Two of the older girls quietly arose, removed her sunbonnet—smoothed her hair, adjusted her little black cap and led her gently to a bench nearby—an act so spontaneous, so considerate that it was an effort for those of us who saw it to keep the tears back."[7]

Johnson Brigham, publisher of the *Midland Monthly*, encouraged her to continue writing, and the support brought her to a turning point. In a 1921 *Palimpsest* (the magazine of the State Historical Society of Iowa), the editor noted that Brigham's support "led not only to her book on the Amanas but also to a long list of articles on the same subject."[8] Her articles appeared throughout the United States and Europe during the next forty years. As in all her writing on Amana, this earliest piece emphasized religious commitment: "not a thing to be put aside Monday morning with the 'best clothes' and donned on the following Sunday, but a thing ever present with them, a part of every-day life."[9]

She soon began freelancing, writing short stories as well as articles on natural science and other topics. Benjamin had returned by then and joined the University of Iowa faculty in January 1896. They married the following year, and Benjamin established his career amid a whirlwind of academic change at the University of Iowa. He was among the renegade young professors who helped create the university's undergraduate academic departments as they exist today. Similar efforts across the country replaced all-encompassing "collegiate" programs with specialized undergraduate majors and graduate-level professional schools.[10]

Shambaugh took over as head of the department of political science in 1900 and continued in the position until his death in 1940. He forged a bond between history and political science as a volunteer who brought order and scholarship to the fledgling State Historical Society of Iowa. At the time, the society's dusty and haphazard collection of books and artifacts filled rooms above a hardware store. But in 1901 he moved the headquarters on campus to Schaeffer Hall, the university's first fireproof building and one that shared a hilltop crowned by Iowa's Old Capitol building. He earned $2,000 a year as a professor and

lamented in a 1905 journal entry that the regents refused him a raise because he also made $400 a year as superintendent of the historical society, a post created in 1907. But at a time when the average laborer earned about $1 a day, Benjamin's professor's salary alone supported a comfortable lifestyle.

The Shambaughs built a rambling Queen Anne–style frame house at 219 North Clinton Street. Construction cost $4,910; the heating system, $500; the plumbing, $350; and wiring and gas and electric fixtures, $120.[11] As the house was built, the Shambaughs lived in the Cox home across the street, while the Cox family resided in Paris, where Arthur Cox worked for a year. In 1902 Bertha and Benjamin moved into their completed home, with its gray-painted exterior reminiscent of the weathered gray of frame homes in the Amanas.

Turn-of-the-century Iowa City, according to university historian Stow Persons, "was a placid and somewhat isolated community. . . . Both faculty and students, who were almost all native Iowans, shared a conviction as to the superiority of Iowans and the Iowa way of life, balanced by a somewhat morbid sensitivity to the presumed condescension of Easterners."[12] The Shambaughs did their best to dispel such attitudes. Their residence quickly became a mecca for celebrity visitors to the university from around the world. Bertha Shambaugh reigned as a legendary hostess of whimsical dinner parties honoring the writers, social reformers, and political leaders her husband drew to speak at the lecture series that he launched at the university. The series featured a hundred prominent speakers over several years, and Bertha is credited with not only entertaining them but writing the witty introductions Benjamin delivered for each guest. Listeners found her entertaining quips a welcome relief from the flowery welcomes of the day.

Bertha and Benjamin Shambaugh come back to life out of forty-eight archival boxes at the University of Iowa special collections and a dozen more at the State Historical Society, in addition to the society's collection of Bertha's artwork and photography. The archives offer a richly detailed picture of social, political, and personal issues cutting across sixty years. They include letters, receipts, manuscripts, diaries, and Bertha's "housebooks." These alone cover more than 6,000 pages in a series of hardbound stenographer's pads. The housebooks record the friends, family, and VIPs who dined at 219 North Clinton and document the menus and entertainments for the dinners as well. Everyone from Hamlin Garland, Jane Addams, and Grand Duke Alexander of Russia to homesick graduate students in need of advice found their way to her door.

According to Kathleen Bonann-Marshall's research on the history of the Shambaugh home, "during the first six and a half years of its occupancy 'The House' (as the Shambaughs referred to it) entertained 1,700 guests on 148 different occasions. And this was before the Shambaugh's devoted and capable Agnes became housekeeper [in 1905]. With Agnes managing all the practical needs of entertainment, the House became even more socially ambitious: in the fall of 1913, for example, there were 4 dinners, 3 luncheons, and an evening party—171 guests in 26 days."[13] Local stores provisioned the dinners from orders that Benjamin phoned in at Agnes's direction. There were groceries from Younkin's, candy and ice cream from Reichardt's, and meats from Nittenmeyer's. Schneider's rented chairs as well as offering furniture for sale, picture-framing, and funerals.

Although Bertha frequently brought home baskets of food and other goods for the dinners from her visits to the Amanas, she focused her energies on extravagant floral arrangements, with vines that often draped down the sides of the dinner tables, and other decorations such as handcrafted butterflies or birds hung from the chandelier. She made Wimpuses, whimsical creatures crafted partially from marbles, and other party favors that found their way home with visitors. Poems, presents, or satirical speeches provided the entertainment for dinners celebrating visits of VIPs or for family gatherings on birthdays and holidays. Benjamin and Bertha kept the conversation lively too with lists of conversation topics that they composed at breakfast. Bertha typed the list and placed a copy beneath each of their plates. They were a dashing and captivating pair, as Bertha's photographs from the early years of their marriage show.

The Shambaughs' guests, according to a former student, "felt the spirit and personality of Professor Shambaugh as soon as we crossed the threshold. There in the front hall was his beaver hat, and immaculate gloves lying on his green academic bag in the seat of a chair of historic wood. And nearby was his cane rack with its collection of anniversary canes with their silver bands. And there was 'the chief' with his welcoming smile."[14] Benjamin had a theatrical streak marked by his dapper dress—silk kerchiefs and ties, handmade shirts ordered from Marshall Fields in Chicago, and a felt hat tilted just the right way. Fastidious as well as fashionable, Benjamin had a place setting of dishes for his use only.

Even though they did not have children of their own, Ah B (baby talk for Aunt Bertha) and Uncle Benjis loved to entertain their nieces and nephews. Katherine, Benjamin, and Harold Horack, the children of Bertha's brother Claude, lived only two blocks

away and visited frequently. (Benjamin had introduced their mother, one of his students, to Claude.) They and other neighborhood children flocked over on Sunday afternoons to read the "funny papers" in Ah B's big city newspapers and to hide under the fearsome animal rug in the front room. Bertha brought them trays of cookies and "cambric tea," which was mostly warm milk and sugar flavored with a few teaspoons of the coveted adult beverage.[15] The children also helped with dinner parties. Katherine Horack Dixon remembers that "my cousin and I [would] open the doors, and we children knew where to put the coats. The women's coats went to the main guest room and the men's coats went to the closet. They liked to include us and it gave us an interesting point of view because we got to meet all the lecturers."[16]

Women in polite society were expected to go calling on friends each week and to specify afternoons when they would be "at home" to receive callers. "Monday was her at home day," Dixon recalls. "There was a stream of guests. Most of them would be Uncle Benjamin's students . . . and I think particularly the graduate students who came from abroad. I think they often brought some of their problems to her. It was someone with whom they could talk about their families."[17] Photographer F. William Miller's daughter, Louise Miller DuVal, was among the students Bertha "adopted," and the young co-ed roomed at the house with her when Benjamin was out of town and Agnes could not stay. The DuVal's ornate clock stood for years on the mantle in the Shambaugh house, and a note that directs it to be returned to the Miller family, from whom Bertha had borrowed it, is still inside it.

The Shambaughs never owned a car but hired a local cab and driver for frequent trips out West to the mountains and national parks. They never went to football games, and Bertha scoffed at the construction of a new university stadium. "Isn't it a shame? They've put all this money into a new stadium and now football is going out of fashion," she wrote.[18] They preferred walks in the woods, poetry readings at the Cox home, and lectures at the Unitarian Church. They were avid gardeners, and Bertha, who never missed an accolade where Benjamin was concerned, credited him with "the most perfect lawn in Iowa City." They bought hundreds of flower bulbs from Bancroft's in Cedar Falls, where tulip bulbs cost seventy-five cents a dozen. When the Shambaughs spotted fraternity boys plucking tulips for their girlfriends, the couple typed messages to hide in the flowers. The tiny slips—reading, "This, courtesy of Benjamin Shambaugh's garden"—presumably fell out upon the dresser of many a sorority girl when the blossoms fully opened.

This was the light-hearted side of a seriously intellectual couple who relished other playful jokes. "We called at the Linder home [April 8, 1905] and I told Fred Fitzpatrick that he could catch birds and butterflies by sprinkling them with salt. What fun it was to see him try it," Benjamin wrote in the journal he kept that year.[19] Bertha applied a sense of humor even to the tasks she undertook to help her husband. She noted with witty hyperbole that she was completing the "edition 16,000" of the syllabus for his famous campus course—an entertaining history of culture that Benjamin ran more like a popular lecture series than an academic class.

Where Benjamin was concerned, Bertha Shambaugh was the quintessential Victorian woman and exceeded the ideal of the devoted wife even by the standards of her day. Godey's *Ladies Book* and other periodicals espoused making the husband the king of the household as the surest path to domestic bliss. Once they married, Benjamin easily became the center of Bertha's world, and he relished the role. But Bertha also continued to draw, photograph, write, and publish articles, reflecting her own independence and ambition and years of slowly changing attitudes about women. Iowa journalist Nellie Rich already recommended a larger sphere of pursuits for women in her 1870s column, "The Household," which ran in the *Vinton Eagle*. "Let no woman be deterred from any good and profitable employment for which she is fitted by fear of ridicule or opposition," she advised in 1873.[20] "Away and forever with the idea that married women can make no progress in study. It is difficult sometimes to make women believe this and to dispossess them of the idea that marriage is an insuperable barrier to education," she admonished in 1877.[21] Susan B. Anthony and the National Woman Suffrage Association she had helped create continued to fight for rights for women on a national scale. In addition to being strong supporters of women's education and suffrage, the Shambaughs believed in such radical notions as civil rights for minorities. But they drew a sharp line between social reform and libertarian behavior. Bertha laid out her strict standards for decorum in a lecture for freshman women and called upon them to be duly shocked by the young ladies, in a scandalous episode she reported to them, who had actually allowed young gentlemen to lift them in the air.

Benjamin was a national figure in political science by the early 1900s and frequently traveled as an invited speaker to eastern cities. He helped found the American Political Science Association and the Mississippi Valley Historical Association (later the Organization

of American Historians), and organized and directed the Commonwealth Conference, a national academic conference that discussed matters of national policy. "He planned, directed the research of, edited and [saw] through the press more than 75,000 pages of historical and political literature," Bertha wrote after his death in 1940. "He launched the *Iowa Journal of History and Politics*, now in its 30th year. *The Palimpsest* [which he inaugurated in 1920] was the first popular monthly of state history to be published in the United States."[22] He also made the university's department of political science nationally prominent and developed graduate and doctoral programs on his own, while maintaining a full load of lecture classes and seminars.

Bertha affectionately invented the term the "strenuous Benjamin" to describe a man who pushed himself to exhaustion to fulfill an ever more arduous schedule of teaching, writing, lecturing, publishing, and administration. She freed him for his work wherever she could, editing his manuscripts, typing them for publication, proofing galleys, and making maps and charts. Benjamin loved his work but constantly fumed over decisions of the university's board of regents, patronage appointees of local politicians in that era. "Think of a board of politicians sitting in judgment upon the work of university professors! Think of a cross-roads lawyer judging the competency of trained scientific minds, think of a village banker deciding the problems of minority education," he huffed in his 1905 journal when a professor was asked to resign.[23]

While so much of the folklore about the couple focuses on her worship of Benjamin and her success as a hostess, Bertha Shambaugh undertook the massive research effort for her history of the Amana society in the early years of her marriage. Even before *Amana: The Community of True Inspiration* was published in 1908, she was considered the expert on the colonies, and the Iowa Department of Labor had asked her for a report on the colonies for their biennial publication in 1902. Benjamin supported her projects and offered encouragement, suggestions, and the research tools for the book. He believed that historical research should focus on local issues and the lives of everyday people—common practice today but a revolutionary approach for the early 1900s. And he insisted on field observations, essentially applying scientific methods to the study of history. It was a time, according to Bennett, when there was "a lot of professionalization going on in the social sciences, whether it's political science or history or anthropology, and Benjamin and Bertha are right on the cusp of that [change]." Adopting this approach for her articles, labor reports,

and books, Bertha interviewed countless people in the Amanas and addressed long letters filled with questions to Dr. Charles Noé, author of *A Brief History of the Amana Society*. The questions ranged from whether any Amana child had ever been sent to reform school (answer: no) to the number of "traveling men" selling Amana products on the road (answer: ten). For her 1908 book, she studied community documents, including the dozens of volumes of inspired testimony by Barbara Heinemann and Christian Metz. The volumes, all published in German, posed a daunting challenge because Bertha Shambaugh did not read or speak German. Fortunately, she had ready access to graduate students whom she presumably hired to translate the texts, from which she quoted at length to emphasize the spiritual foundations of the colonies. As she had in the *Midland Monthly* article, Bertha combined factual precision and entertaining anecdotes in her book. In addition, she embodied the religious foundations of the Amanas in stories of real people.

The book devoted 156 pages, approximately forty percent of the text, to Amana religious practices and beliefs. But that still left her lots of space to zero in on other colorful characters and customs. She reported how the Amana hotelkeeper, who doubled as the marshal for the community, was judged a "holy terror" by the hobo community: "His naturally keen eye has been trained by years of observation and experience to distinguish between the professional tramp and the really unfortunate and worthy wayfarer" in temporary need of a bed and meals in one of the Amana's hobo hotels.[24] (The "worthy wayfarers" usually stayed for a while and provided itinerant labor in the Amanas.) Shambaugh wrote the book with an unpretentious vivacity that starts with the first paragraph: "In one of the garden spots of Iowa, there is a charming little valley from which the surrounding hills recede like the steps of a Greek theater. A closer view reveals seven old-fashioned villages nestling among the trees or sleeping on the hillsides."[25]

As a final flourish, in preparation for publication of the book, Bertha Shambaugh took her famous self-portrait in Amana dress. It was Benjamin's favorite picture of her. She borrowed the dress from her good friend Marie Miller Haas, a beautiful young woman whom Bertha described as possessing "a strange power in her quiet manner that bespoke of her ancestry."[26] Haas was the great-granddaughter of Christian Metz, who led his church to the promised land of the United States.

The State Historical Society of Iowa published the book, but Bertha Shambaugh footed the bill for all the years of work, all the translations, and even the typewriting, as she

remarked in a letter in response to criticism that her husband had used state funds to support her project.[27] The book received widespread and favorable reviews in newspapers in Iowa City, Cedar Rapids, Chicago, and elsewhere. It was so popular that Bertha had her five-by-eight negatives copied onto lantern slides. The 2¼-by-2¾-inch glass lantern slides fit into a front panel of a kerosene lantern projector, which provided the light to project the images on a screen to accompany lectures she gave.

Shambaugh dedicated the book "To my mother, whose beautiful life will be an ever present inspiration to her children." Shortly after she completed the manuscript, Katherine Horack fell ill with leukemia and moved into the Clinton Avenue home where Shambaugh nursed her. Her mother's death in 1909 halted her nonstop rounds of commitments. "All that I am I owe to her," she mourned. She placed flowers at her mother's photograph for the rest of her life.

Entries in the housebooks suddenly halt for more than a year. High-strung and temperamental, Bertha suffered a serious bout of depression diagnosed by a Chicago specialist as "neuralgia." He ordered rest and sedatives. But as the symptoms lingered, Benjamin devised a better cure. He arranged for a six-month tour of Europe for Bertha with a university friend and the friend's two nieces. Bertha left Benjamin and her household in the competent care of Agnes. The party took the train to Chicago on April 28, 1910, transferred to a train to New York, and embarked on a ten-day cruise to London as first-class passengers on a steamship.

Bertha kept a diary and wrote enthusiastically about the hotels, museums, and scenery as they traveled to Paris, Brussels, Frankfurt, Heidelberg, Berlin, Dresden, Lucerne, Rome, and cities in Spain. Her travels in Germany took her to the Ronneburg castle, the historic home of the Community of True Inspiration. The front of the diary lists the recipients of dozens of postcards she sent to friends in Iowa City and the Amanas. But the diary gives way to expressions of homesickness on the occasion of her thirteenth wedding anniversary and heartache when she thinks of her mother. "It was one of the most interesting experiences I have ever had to walk through these old halls and . . . climb the same steps and look out the same windows as the early Inspirationists did," she wrote.

Bertha's photography changed with the trip. She carried a portable camera and took tourist pictures of famous landmarks such as the Leaning Tower of Pisa, frequently posing in front of them with her friends. These are the last photographs credited to her, and they

call to mind casual tourist snapshots rather than the artistry of her glass plate negatives. The long exposure times and cumbersome procedure of carrying each negative in a film holder necessitated a rigor of composition that had obviously appealed to the early Amana photographers as well as to Shambaugh, and their discipline and technical mastery reaped astounding results. Photography apparently lost its charm for Shambaugh, as it did for the first generation of Amana photographers, when the challenges posed by view cameras and glass plate photography gave way to snapshot cameras and rolls of film sent off to the local processor.

Back in Iowa City, Bertha turned to writing for children. She wrote stories to go with the animal and human characters she created by decorating cookies for the amusement of her nieces and nephews. She pursued options for publication in the 1920s. The book never materialized, but cookies appeared each year on the Shambaugh Christmas tree. She also fashioned dolls out of cornhusks for a project sponsored by the Iowa Federation of Women's Clubs for the Iowa booth at the 1926 U.S. sesquicentennial celebration in Philadelphia, where "King Corn" and his retinue promoted corn products and Iowa with light-hearted charm. For another unpublished storybook, in which all the key characters were frogs, she made lovely watercolor illustrations and many pencil sketches, reminiscent of those accompanying Beatrix Potter's "Peter Rabbit."

Except for their vacations in the West, Shambaugh rarely left her house by this time because of a hearing loss, a problem that plagued both her brothers as well. Everything she needed could be delivered to the house. Katherine Dixon recalls that even dressmakers came to do fittings for the two piece suits that had become her "uniform."[28] In the early 1930s, she started to review and index her voluminous housebooks, adding lengthy handwritten notes. She filled in details and philosophical observations in empty spaces that remained among her earlier, exuberant entries about guests and menus at the dinner parties. The annotations cease in mid-1932, when Amana's leaders turned to Bertha Shambaugh for a defense of their new world.

The Great Depression and internal pressures brought about the Great Change within Amana, an economic shift that turned the society into a corporation that would take over management of its properties and lands. The Amana people became shareholders in the new corporation and earned wages for their work for the first time. The church continued as a separate and independent institution. Amana families, who had been victimized as

German sympathizers during World War I because of their rejection of mainstream American society, were pilloried for joining it after the Change. Although there was also positive commentary on the Change, Shambaugh undertook the task of revising her Amana history to set the record straight. She published the updated volume in 1932 under the title *Amana That Was and Amana That Is*.

Shambaugh continued to take aim at detractors with a spitfire response to a vitriolic article about Amana's "departed glory" published in 1935 in *Christian Century* magazine and excerpted in the *Des Moines Register*. She demolished the authority of the author, Marcus Bach, by pointing to factual errors regarding Amana customs, which she accounted by concluding that the author had never visited the colonies. She warmly defended Amana's foresight in averting bankruptcy and the social dissolution that had claimed so many religious utopias.[29]

According to a letter Bertha wrote to one of her husband's former students, Benjamin too was still "sparking on all cylinders" in 1940. Within a short time, however, he suffered a fatal heart attack. "My whole world has been so completely shattered that everything . . . has lost its meaning," Shambaugh wrote in one of her housebooks.[30] She mourned his passing with an elaborate memorial service that began with the ringing of the long silent bells of the Old Capitol, the former state capitol building. Colleagues, politicians, and friends lauded him in eulogy after eulogy, which the next day's newspapers covered in great detail. Bertha continued to deify her husband's memory for the rest of her life and even cordoned off his chair at the dining room table with a silk ribbon. She collected his papers for his archive and wrote sketches of him and his family for a biography that was never completed. In 1950 the *Palimpsest* reprinted excerpts from the 1932 Amana history, *Amana That Was and Amana That Is*, with a portfolio of modern Amana photographs by William F. Noé and several old classics by Bertha Shambaugh. This was the last publication of her Amana work in her lifetime. She died on Feb. 12, 1953, in an Iowa City nursing home.

The Shambaughs had set clear boundaries between public and private documents. They destroyed personal letters to each other, and Bertha Shambaugh penned a note on the first page of her journal from the European trip, directing that the diary should be destroyed. She wrote similar instructions on other papers. Fortunately, however, curators at the historical society and university libraries had the foresight to preserve everything.

More than two hundred of Bertha Shambaugh's glass plate negatives and lantern slides are preserved at the State Historical Society of Iowa, but many of her original negatives of the Amanas are assumed to have been destroyed. Small collections of these originals survive at the historical society, at the Museum of Amana History, and in a private collection. Only copies made for lantern slides exist of the remainder, unless the originals have come to rest in some stray box among Shambaugh's relatives and friends.

Bertha Shambaugh's photographs continue to be reprinted in the Amanas and elsewhere. She created an equally valuable legacy by opening the door to photography in the Amanas, where hundreds upon hundreds of turn-of-the-century images document a communal religious society as it was seen by its own members.

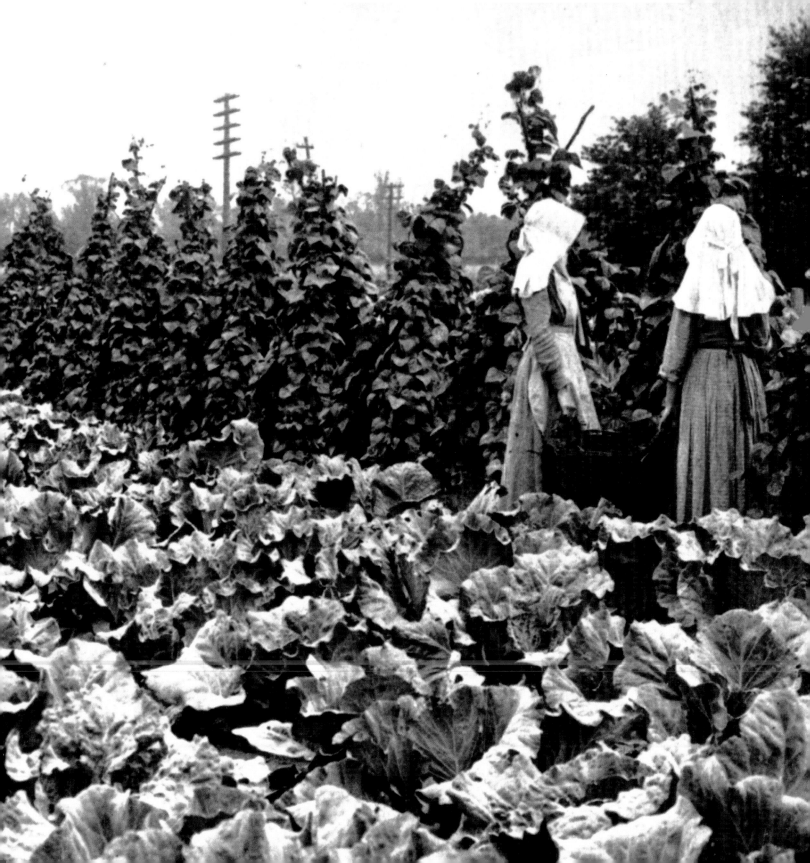

The Amana Experience

The seven Amana Colonies unfold like a European tapestry across 26,000 acres of hills and hollows along the Iowa River. Middle, High, West, and East Amana slope down toward State Highway 220 from a natural ridge. South Amana and Homestead hug the rails of once mighty passenger lines that have since been replaced by Interstate 80. All the towns link to the central village of Amana. The river valley cocoons a pastoral paradise of open fields and forests where the villagers could roam freely outside the confines of their tightly structured religious society.

The Community of True Inspiration that settled the Amanas moved its members across two continents to escape Old World persecution and preserve isolation from New World distractions. Rugged determination to pursue their faith in exile kindled a self-reliant individualism that seemed at odds with religious communalism. In fact, both individualism and communalism reinforced the successful self-sufficiency of communities that produced almost everything they needed, from food and wine to furnishings, harnesses, rugs, and cloth. The crafts prized throughout the colonies became a springboard for an outpouring of folk art, painting, and photography. Arts and crafts in turn allowed individual expression in a society in which clothing, meals, households, and religious worship were relatively uniform.

Other Amana customs allowed for individual and artistic expression as well. "The element of individual freedom in the Amana Colonies has always been more or less disturbing to the theorist," notes Bertha Shambaugh in her second book on the colonies, updating the history of the Amanas to include its reorganization into a capitalistic economy. Looking to the past, she concludes: "Admittedly, Amana's village system was not economical. But it fostered a rather precious spirit of independence. While the house in which a family lived was community property, home was ever the sanctuary where its members, old

and young, enjoyed a wholesome sphere of privacy and domestic independence."[1] In addition, Amana gave people the gift of time. Lots of it was needed to attend the eleven religious services every week. Unlike most farm families, however, the Amana people did not have to worry about caring for stock, mending broken harnesses, or chopping timber after the regular day's work. The jobs were delegated, freeing people to pursue personal interests. Crafts of all kinds were very popular. A brief history of the colonies will help explain the content of many Amana pictures and, equally important, the social and aesthetic values of the photographers who made them.

The name Amana, meaning "to remain faithful," is drawn from the Song of Solomon in the Old Testament of the Bible. The colonies represented a bright dream played out in dozens of communal religious societies throughout the United States during the nineteenth century. By the 1930s, the Amanas were among the oldest, largest, and most prosperous of the communal societies that sought to create a cradle-to-grave sanctuary for religious devotion. They stand out for their ability to make a successful transition to mainstream America after a 1932 vote that is simply called the Great Change. The Amana church survives nearly three hundred years after its founding as a small German religious sect.

The Amanas had their roots in Pietism, the spiritual revival that erupted in seventeenth-century Europe in response to continual wars between Catholics and Protestants and repression by both groups of new religious practices. The repression and uncertainty resulted in an outpouring of the Pietist's mystical religious expression. Members fell into tremors and trancelike states and "testified" to God's word aloud during services. Trust in the divine inspiration of the testimonies provided the cornerstone of Pietist faith. The Pietists believed that the presence of God within each human being allowed people to carry His messages directly to the faithful.[2]

The Quakers and Shakers believed that God could speak through any member of the congregation. The Community of True Inspiration believed God spoke only through prophets—called "Werkzeuge," or instruments—whom He regularly inspired to speak. In both instances, belief in divine testimonies fulfilled the spiritual longing for direct contact with God sought in all religions.

The revival meeting atmosphere of the Pietist services made them appealing, along with the promise that any human being could be worthy to deliver God's words. Pietists gathered in each other's homes, as had the early Christians, who became the model for the

self-sacrificing devotion of the new movement's members. Worshippers would pray, sing, or simply wait in silence until one member fell into a trancelike state and gave his or her voice in testimony to God. A hush of wonder would fall over the service, for the members of the congregation believed they were hearing God speak directly to them—personally to them—through His chosen instrument. In early pietist meetings, a cathartic frenzy of songs and prayers would follow the awakening of God's spokesperson, who had no memory of what had been said.

The Pietists believed that people needed to focus on God and live rigorously pious lifestyles to receive these messages. They rejected the social order around them as worldly and materialistic. Although such views invited repression, the Pietists spread their faith as they fled from one place to another. They began to band together into communities in areas of England, Germany, and Switzerland where they could worship in peace—for awhile. In England, the Pietists evolved into the Society of Friends. The convulsions that accompanied early testimonies of the society earned them the name "Quakers" (by the eighteenth century they no longer "quaked" but pushed for sweeping social and education reforms in England and America).

In Germany, the immorality and religious indifference among rich and poor alike expressed a disenchantment with established religions. The Reformation had failed not only to resolve conflicts between the classes but also to maintain the personal religious fervor it had set out to rekindle. By the late 1600s, people seeking social reforms and personal spirituality in religion felt betrayed.

In 1714 Eberhard Ludwig Gruber and Johann Friedrich Rock, two religious leaders who had been Lutheran ministers, formed the Community of True Inspiration and held the first Liebesmahl. Gruber's charismatic son Johann Adam soon took the leading role in the community. He gave the first inspired testimony, consisting of a single word, "Werkzeug" (instrument). The word expressed the central Pietist doctrines that God continued to choose his followers as the means to communicate His messages, that the chosen in no way controlled these communications, and that the inspired testimony they delivered ranked with the testimony of the Bible. Johann Gruber's bold and heated testimony about a new spiritual awakening from the immorality and injustice of established government and religion won him an ardent following.

Gruber, Rock, and others became missionaries, traveling across Europe and establish-

ing small congregations. Their incendiary doctrines, their pacifism and refusal to serve in the military, and their refusal to send their children to state schools won the wrath of the clergy and civic leaders alike. The trancelike or frenzied outpouring of their testimonies made them an easy target for repression. Magistrates and religious leaders pointed to Gruber in particular as dangerous and possessed. Gruber overcame his own fear that evil spirits spurred his inspired words because the intense joy they brought to him and all those around him convinced him that they were truly the words of God. Now, he stood firm and the Inspirationists trusted him with their lives in adhering to their beliefs.

When the Inspirationists in eighteenth-century Zürich were pilloried, then marched and flogged through the streets that ran red with blood as each received sixty-two lashes, they submitted because they were pacifists.[3] Facing constant imprisonment and confiscation of property, the community migrated to the more liberal German province of Hessen, where they lived in relative peace. After the death of Gruber in 1728 and Rock in 1749, no new Werkzeug appeared for nearly seventy-five years, and the Inspirationists fell into decline. The elders of the new community downplayed their unpopular religious ideas, and community members joined the mainstream of Hessen life in a period of peacetime prosperity.

A new Werkzeug awakened the old religious spirit in 1817 in the medieval village of Ronneburg. Michael Krausert's inspirations coincided with a new period of war and social upheaval—and a new period of repression. Krausert fled in the face of government persecution and mutiny by the elders. But the mystical faith he expressed in testimonies in the shadow of the Ronneburg Castle endured long enough to draw into the fold an illiterate servant girl named Barbara Heinemann and a carpenter named Christian Metz. They would become the new Werkzeuge and would lead the Community of True Inspiration in an odyssey across Germany, the Atlantic Ocean, and the United States to the frontier state of Iowa.

In Bertha Shambaugh's view, "the story of Barbara Heinemann is one of the most interesting chapters in the history of the Community of True Inspiration. . . . Her parents were so poor that at an early age she was sent to a neighboring factory to earn a pittance spinning wool . . . but, like the Maid of Orleans, she dreamed dreams and saw visions. . . . It was in an effort to interpret these dreams and visions, these 'continual inward promptings' that she sought out the little group of devout Pietists of whom she had been told."[4]

Heinemann's inspirations began shortly after she was admitted to meetings: "I was released from my worldly service as servant girl since the Lord, as announced by Brother Krausert, desired to take me into His service and use me as His handmaid."[5] With the Bible as her only primer, she learned to read and gave testimonies that echoed the Old Testament in style.

Heinemann's fiery, judgmental positions contrasted markedly with Metz's calm, compassionate insights. Metz, though a prophet, was also a brilliant organizer. Rock and Gruber had channeled the Pietist movement into a specific religious community governed by the Twenty-four Rules of Godliness. Metz extended the idea of a religious community into actual communities in which people could live and work together. As he would many times in the coming years, he turned his attention to finding a sanctuary where the Inspirationists could escape a new wave of persecution that inevitably caught up with them in Ronneburg.

Metz settled the group in nearby Arnsburg in an abandoned cloister that the Inspirationists leased. They also leased an abandoned convent and two other estates. The four settlements, located within a few miles of each other, each joined a cross-section of German society in terms of wealth, social class, and skills needed to sustain a self-sufficient society. Each community had living quarters, a church, a school, and farms. As in the Amanas, the communities established workshops and industries that allowed craftspeople to continue in their trades. While the ownership of private property was maintained, members shared resources with each other. According to Shambaugh, "the rich gave freely of their means, the merchants of their business ability and the artisans and farmers of their labor. It was not long before the community attained a degree of prosperity which promised the free, simple, quiet and peaceful life foretold in the early prophecies."[6]

But with revolution sweeping Europe, the government and aristocracy became ever more autocratic and suspicious of nonconformists such as the Inspirationists. Once again, freedom of religious worship eroded and persecution followed. Now Metz received an inspiration to take his flock to America, and he traveled to the United States with a committee of Inspirationists. The community bid them a moving farewell on August 27, 1842, during the holiest of Inspirationist services, the Liebesmahl. The committee purchased the 5,000-acre Seneca Indian Reservation, from which the tribe was departing, near Buffalo, New York. They added another 3,000 adjacent acres and called for the Inspirationists to journey there. Eight hundred arrived in the first few years.

With each spring, more people came to the new land, building identical, unpainted frame houses that lined the streets of six villages: Ebenezer (later called Middle Ebenezer), Upper Ebenezer, Lower Ebenezer, New Ebenezer, Canada Ebenezer, and Kenneberg. Each community had a store, school, church, and, once again, several industries. Families contributed to the establishment of the communities as their means allowed, and all property purchased was owned in common. Historians have adopted the term religious communalism to describe the religious societies that adopted a communistic economy but had no political ties to communism. As Lanny Haldy explains, the Inspirationists' "experience on those estates in Germany might have predisposed them to communalism but they didn't know it was a possibility until they got to America" and encountered the example of other religious communities. In any case, the Ebenezer colonies were to abandon this system of religious communalism after two years. Metz quickly realized, however, that the wage opportunities in booming Buffalo would draw the poorer and less-educated members away.

In inspired testimony, Metz sealed the fate of the Inspirationists: "He who serveth his church serveth God may it be by the labors of his hands, his mind or his soul or by surrender of his worldly goods. So all shall belong to the church and the church shall provide for all."[7] The inspiration formalized religious communalism as the economic base for the colonies. Metz invited any who did not agree with the system to leave; all property contributed to the common fund would be returned to those who chose to withdraw from the community. Few departed, and the Ebenezer years marked a happy time for the Inspirationists, who could finally pursue their faith without fear of punishment. They soon faced another crisis, however. The Buffalo area burgeoned in population amid the largest mass immigrations of Europeans to the United States. More than 4.3 million people—most of them German, British, or Irish—settled in the United States in the 1840s and 1850s. Ebenezer itself grew substantially from its original population of 800.

With worldly temptations creeping closer, Metz led another committee on a fruitless search for land in Kansas. An inspired testimony he delivered in 1854 targeted Iowa as another potential home, and the community sent scouts to a frontier territory that had been made a state only ten years earlier. With a favorable report from the scouts, Metz and a committee embarked on his fourth journey in as many decades. This final pilgrimage would bring the Inspirationists to a permanent home. In 1855, the committee arranged to

buy 26,000 acres of some of the most fertile land in the United States. They paid $1.25 an acre for portions owned by Congress. Land purchased from earlier settlers cost a bit more, depending on improvements.

The community incorporated as the Amana Society in 1859 and adopted a constitution similar to the one in Ebenezer, covering the contribution of all property to a common fund and reiterating the guarantee of a return of all property if members should leave. The migration from Ebenezer continued over the next ten years, with new members from Germany and Switzerland also joining the community. The colonies accepted members only on religious grounds, however, and rejected dozens of petitions to join the society from socialist political thinkers. Between 1854 and 1862 the Inspirationists established seven colonies in Iowa, including the existing village of Homestead, where the Society bought the property of all the residents to gain a railroad stop. The Mississippi and Missouri Railroad (later the Chicago, Rock Island, and Pacific Railroad) extended service to Homestead in October 1860.

The Amanas shared the American utopian religious landscape of the nineteenth century with the Shakers, Harmonists, Ephrata, Zoar, Bethel-Aurora, and Oneida groups. At their height, the Shakers had fifty-eight communities and 6,000 members, but their strict belief in celibacy eroded membership. Spirited revivals and even community orphanages did not add enough new members to replace the older Shakers when they died. Although the Amanas allowed marriage, they viewed celibacy as a superior spiritual state. Barbara Heinemann offered a living example. She married George Landmann in 1822 and lost the gift of inspiration for seventeen years, regaining it a few years before her husband's death. Though pragmatic about marriage, the colonies forbade matrimony until a girl reached her late teens. The devotion of a young couple in the early years of the society was tested by separating them in different villages for a year. If a young woman became pregnant before marriage, she and the baby's father had to publicly admit their sin and apologize before the entire church congregation. Usually, they married immediately, but marriage was never forced upon an unwilling young woman, and the regard for celibacy meant that unmarried and widowed women in the Amanas were respected. Widowed mothers could easily remain single, because the entire community helped to support them and their children. These conditions contrasted sharply with the lot of of single women in American society as a whole, where women who never married were called "old maids" and single mothers

often faced abject poverty for themselves and their children. The church encouraged celibacy even within marriage, and, although there were many large families in the Amanas, the colonies had the lowest birth rate in Iowa.

Men and women ate separately in the community kitchens and sat on separate sides of the church, but private homes, often occupied by three generations, preserved traditional family life. The Amana home contained utilitarian, hand-carved cherry and walnut furnishings, handwoven rag rugs, and handcrafted clocks and housewares—all now prized as antiques and still made in reproductions today. The beautiful handicrafts filled rooms with high ceilings, large windows, and walls painted in whitewash tinged with cobalt to a robin's-egg blue. The Amanas discouraged burdening lives with worldly goods, and few families could afford many "store bought" luxuries from outside the colonies. But each family had an account book for credit at the general store, where gift items, shoes, oranges at Christmas, and other things not made in the Amanas could be purchased. Wine was one pleasure that was not forbidden. Each man had a wine allowance of twenty gallons a year; each woman, ten gallons. People also made their own wine from the Concord grapes grown on vines that blanketed the trellised houses. The account book "was the most important book next to the Bible,"[8] quips one former custodian of the Amana museum.

Both men and women—including young mothers—worked; the society provided women with an early equivalent of leaves of absence of two years after childbirth. Older women, who were often grandmothers, ran the Kinderschules (kindergartens) that provided child care for the little boys and girls and taught them games and prayers. The women also instructed the girls and boys in knitting lessons as part of the elementary school curriculum. Everyone went to work after graduating from the eighth grade. Men worked the farmlands and barns, filled the jobs of carpenters and artisans, and served in professional posts. All the elders were men, and even Barbara Heinemann was excluded from their ranks. Jobs were assigned as needs arose. Women worked in the gardens and kitchens in addition to doing their household chores and sewing clothing. A few had jobs in the woolen mills.

The population of the colonies peaked at 1,813 in 1881, when the communities were flourishing. Despite the quaint villages and old-fashioned dress, the Amanas embodied distinctly American traditions planted by the Puritans and Quakers, with whom the Inspirationists shared religious philosophies. Though these religions had no direct connection

with Amana, the Amana constitution reflected the Puritan ideal of a social covenant that allowed a community of the faithful to act as a political entity.[9] Jamestown and many other early colonial settlements reflected this same ideal. In addition, the Amanas mirrored the Quaker and Puritan attitudes toward precise documentation and diligence in business. Business practicality combined with religious fervor from the start, even though the Amana church practiced religious communalism, while the Puritans and Quakers did not.

The mills turned out woolen goods and calico prints that were sold worldwide. The furniture factories sold furnishings and clocks by mail order, and two railroad stops now offered a direct outlet for sending goods to the East. Foods and crafts were popular purchases at the Amana stores early on, and the sale of wine became one of Amana's earliest private enterprises. Tourists poured into the Amanas, first on the trains and then in cars. The villages held the attractions of a getaway to a European setting that was close to home. Ox-drawn wagons provided the first tourist "buses" through main Amana in the late 1890s. But the towns lost their isolation, a key factor in the cohesive fabric of religious fervor and economic prosperity that had set Amana apart from so many other utopian experiments.

Christian Metz, the spiritual father of the community, died in 1867, and Barbara Heinemann died in 1883. By then the conditions of turmoil that had historically brought forth a Werkzeug and religious revival no longer existed in the Amanas. By the close of World War I, most people living in the colonies could not recall ever hearing a Werkzeug. Secular pressures were building by then. The "drone" phenomena—a polite description for those who claimed illness as a reason for not working—resulted in an escalating economic burden to support the "invalids" and pay hired help to cover their workload. Each Amana village had "hobo hotels" for paid workers, who numbered about two hundred at the time of the Change. Amana residents still speak of the Change as a "miracle cure" for illnesses that had prevented people from working for years. Many people who did work also "moonlighted," marketing their own garden produce, handicrafts, or skills "outside." People simply wanted to buy a few extras for their families, but the practice still sapped resources. The more substantial luxuries of cars and trips available to some members of the community, even if they needed them for their jobs, broke down the faith in equality and created a destructive sense of an Amana aristocracy. In addition, many young people left to pursue an education and professions, determined to "get ahead" without the old-fashioned community covenant getting in the way.[10]

Rather than allow the community to crumble into economic chaos, the Amana leaders decided to reorganize. The Great Depression had hit everyone with hard times when the Amanas elected forty-seven representatives—one for each twenty-five people—to map the future for the towns. This group elected a smaller committee of ten to draw up a final plan. The plan converted Amana from a religious communal society into a corporation and church that operated separately. According to the plan, one Class A share was awarded to each person in the community over twenty-one years old. This was a voting share that allowed the holder to have a voice in the election of the board of directors of the corporation. It also entitled the holder to the continued provision of human services, including health care and support of the elderly. Any Amana young person who came of age could buy a Class A share for $50. The rest of the assets of the communities were converted to preferential stock, Class B prior distribution shares divided up among people according to their years of service. People used the stock to buy the homes they lived in. The mills, stores, farmlands, and other property were incorporated into the Amana Society and the Amana people could work for the society for a wage—ten cents an hour for the first year after the Great Change.

The Amana Society and the Amana church continue to operate today. Gift shops, restaurants, and museums have flourished. The Amana Heritage Society sponsors historic reenactments and operates the Museum of Amana History, and the colonies have been designated a national historic landmark.

Amana Photographers *The Insider's View*

The Amana church was rooted in piety and an avoidance of worldly distractions ranging from hair ribbons to photography. Taking photographs or posing for them loomed among the forbidden vanities that carried the risk of expulsion from church services, the only punishment ever needed in the Amanas. Bertha Horack's determination to document the community despite the prohibition showed remarkable spunk on her part and earned fond forbearance on the part of the Amana elders. Her frequent visits and sincere interest in the Amanas engendered trust, and no one wanted to deny her wish to just take a few photographs.

The petite young woman in fact set the precedent for a new historical record that would be kept of the Amanas for the late nineteenth and early twentieth century. While a few scattered images by itinerant photographers have surfaced in the Amanas from the years before Bertha's documentary project, hundreds of photographs were taken in the villages afterward. Despite the ready availability of Kodak cameras (amateur photographers were lampooned by the press as "kodakers"), the Amana photographers chose the more "professional" tools of view cameras and glass plates that Shambaugh herself had favored. Nineteenth-century view cameras were hand-made, beautifully tooled devices with highly varnished wood, gleaming stainless steel fittings, and lavish detailing.

Shambaugh most directly influenced F. William Miller, who was only five years her junior and a young adult when she photographed the Amanas. He was close friends with her younger brothers and a frequent visitor at the Horack and Shambaugh homes while he studied pharmacy at the University of Iowa in 1898–1900. He addressed Katherine Horack as "My Dear Mother" in letters to her and signed them "Your Boy." Miller's photographs documenting the train wrecks, fires, and everyday fiber of Amana life date back to 1898, about two years before Bertha's picture of him in his pharmacy was taken.

Friedrich (Fred) Oehl, Sr., took photographs dating back to the same period and may have bought his camera on one of his many sojourns to sell Amana goods in the surrounding towns, where he drove in the society's Model T. As clerk of the High Amana store, William Foerstner could easily have ordered cameras for himself and others. He and his friend Charles Ruedy, storekeeper at the general store in Middle, and Ruedy's friend John Eichacker, the postmaster in Homestead, all began taking photographs about 1905. Christian Herrmann, Miller's brother-in-law, who was only fifteen at the time, started photographing too.

Shambaugh reports in her 1908 book that the sudden interest in photography resulted in a reminder that it was forbidden and a renewed edict against it, which might have accounted for the number of early photographs taken from hidden perches. "Notice how many early photographs are taken from the top of a building or barn," said Carl Oehl, grandson of Fred Oehl, in an interview. Oehl photographed the crowded Amana streets from the upstairs window of the school on the day of the community's most sacred religious ritual, the Liebesmahl (communion service). William Foerstner set up his camera in the upstairs of the High Amana Church and arranged for a friend to trigger the shutter while he was in the procession for his own wedding ceremony. These are the earliest pictures of each event and remain unique.

Still, the elders were at a disadvantage in attempts to uphold their edict against photography. The powerful social ostracism of temporary expulsion from church lost its stigma. Elizabeth Wetjen, youngest daughter of Friedrich Oehl, recalls her father's being expelled from church for taking pictures but soon returning to religious services without getting rid of the offending camera. "Photography was a perfect example of how people would separate their own faith from religious edicts," according to Lanny Haldy, director of the Museum of Amana History. "They had enough confidence in their religious beliefs to say, 'I can still be a believer and take pictures.' Photography should have nothing to do with religion so you do what you want to do, just like playing baseball, which was also forbidden."

The prohibition had waned by the time the second wave of photographers began taking pictures in the World War I era. Peter Stuck, the first secretary of the Amanas after the Great Change, and Jacob Selzer, the saddlemaker in Homestead, began shooting about 1915. When Selzer died of tuberculosis in 1917, his wife, Henrietta, picked up his camera

and taught herself to photograph. William F. Noé, Rudolph Kellenberger, and his brother, Paul Kellenberger, began photographing in the 1920s and continued after the Change, capturing a new social order that evolved amid the lingering traditions of the old ones.

Historic photographs have provided a rich resource for the history of the community. The works featured here, however, showcase the photographers as individuals who documented diverse aspects of their experience in Amana and explored a wide range of aesthetic possibilities. For photographers working in a society that was so homogenous, the diversity in itself is notable. The portraiture, still lifes, landscapes, candids, and playful fantasies offer in microcosm a cross-section of late nineteenth-century photography.

The diversity and documentary style of even the portraiture contrast with much of Victorian amateur photography at the turn of the century. Typical Victorian portraits were as much about ideals of dress and front parlor prosperity as they were about people. The Victorians tended to create a universal stage set of genteel artifice for their pictures, displaying elegant dress in heavily draped rooms laden with ornate furniture. Photography was the province of the rich and middle class in cities, and the photographs of homes and lifestyles dramatized unwritten norms for fashionable taste whether taken in New York, Iowa, or California. Even middle-class amateur portraits from frontier towns often obscured the mythical West of cowboys and gunslingers with Victorian trappings of starched collars, ruffled dresses and velvet upholstery.[1]

Simplicity, spurned by the Victorians, was the norm in the Amanas and resulted in powerful portraits with a distinct look, because the plain dress and plain backdrops emphasized facial features and expressions. Where everyone dressed alike and home decor stressed practicality, portraits tended to emphasize work or play activities. Women in Victorian photographs typically appear delicate and decorative in their corseted gowns. Women in photographs taken in the Amanas convey strength and competency as they clean, prepare food, sew, read, and even fish. Artisans and farmers, the groups least likely to be photographed by urban amateurs, are photographed in abundance in the Amanas.

At its most basic level as a tool of human communication, photography fulfilled different needs in the Amanas than it did in most other places. Victorian amateurs fell in love with photography as a way to carefully choreograph scenes that represented their definitions of refinement. Photography gave Victorians in diverse circumstances a means to mirror social conformity, while, ironically, it gave photographers from the truly homoge-

nous Amanas a means for individual expression. Dr. Herrmann's medical images, Peter Stuck's botanical still lifes, and Jacob Selzer's hilarious still lifes with his dogs delved into the introspective uses of photography for personal exploration rather than for establishing a picture-perfect record of domestic bliss.

Not surprisingly, the Amana photographers captured an alternative view of the immigrant experience in America. Amana remained a foreign enclave, like many of the immigrant neighborhoods of big cities. Photographs of poverty and squalor in these neighborhoods produced gritty, desperate social commentaries on immigrants. Jacob Riis's frightened subjects frequently look dazed in his ambushes through tenement apartments. Lewis Hine's far more poetic portraits of immigrants at Ellis Island communicate a haunting sense of vulnerability and displacement. By comparison, the immigrant experience photographed in the Amanas radiates a sense of prosperity, cohesion, and confidence. Although the European atmosphere adds a pictorial romanticism to everyday scenes, the Amanas demanded that everything must be useful, and documentation was considered a practical necessity throughout colony life whether in the careful transcripts of testimonies or in the precise record-keeping of business matters. (Indeed, several of the Amana photographers turned their work into successful commercial ventures.) The documentary clarity of so much of the photography reflects in a manner easy to see how the pursuit of photography expresses community ideals as well as an individual photographer's aesthetic.

WILLIAM FOERSTNER, 1881–1974

William Foerstner grew up in East Amana, but after he had completed the required eight years of schooling there, the elders assigned him to assist as a clerk in the general store in High Amana. He lived with the family that managed the store until he married Christina Gernand in 1907 and moved with his bride to the house across the road. He was already taking photographs by then on a beautiful mahogany Korona view camera made by the Gundlach-Manhattan Optical Company.

Photography was still forbidden when William Foerstner photographed his wedding procession from an upstairs window of the High Amana Church. The story remains a prized legend, retold by his daughter, Emilie Foerstner Jeck, who has managed the High

Amana store since her father's death in 1974: "On his wedding day, he set everything up with his camera on a tripod in the upstairs window. Then when the wedding procession was ready to pass, he had a friend go up there and just trigger the shutter with the bulb the camera had." The tilt of Foerstner's head suggests that he looked up toward the camera, probably to signal the shot. He and his bride and all the guests that follow them are dressed in sedate Amana black, a practice that prompted one 1910 observer to remark: "Their weddings are very gloomy ceremonies, and somewhat resemble their funeral services."[2]

Foerstner was one of the earliest photographers in the Amanas and may have ordered his camera and the cameras of some others in town through the High Amana store, though they do not appear on the store's ledgers, which date back to the 1850s. Foerstner moved his family to the home attached to the store when he took over as manager after his boss retired. In the attic storage areas where his darkroom was located, he left behind a time machine of early twentieth-century photography gear: negative carriers, a stereoscopic attachment for his camera, a light meter, a lantern-slide projector for glass plates, drying racks for glass plates, equipment catalogs, and formula charts for mixing chemicals for developer. He obviously could not stock the store with gear that was forbidden, but he expanded the inventory to cover just about everything else.

The Amanas made their own brooms, baskets, wool cloth, yarn, and furniture, and produced most of their own food. Staples such as rice, coffee, sugar, and salt, and metal kitchen and farm implements were among the goods bought outside to serve the whole community. The general stores provided an array of needles, glassware, buttons, fabrics, and luxuries such as hard candy or oranges for Christmas stockings. People made their purchases with a credit account that allowed the typical family to spend only a few dollars per person each year. The stores also sold Amana foods and crafts to the tourists who began to flood into the towns in the 1880s.

Foerstner, however, had an independent, entrepreneurial spirit and a business vision that extended beyond a country store. He turned the High Amana store into a base for a chain of distributorships with outposts in Dubuque and Cedar Rapids. He expanded the Amana Society into a regional distributorship for Brunswick Tires, General Tires, a variety of other automotive equipment, Schwinn bicycles, and even motorcycles. "The High Amana store was still one of the Amana stores, but we sold the tires and automotive supplies all over the area. Dad started the tire business when I was nine years old. When I was

in grade school, I worked after school to help sell the tires," recalls George Foerstner, founder of Amana Refrigeration, the largest private enterprise business to operate in the Amanas. "When I was twelve or thirteen, we started to sell a lot of soda pop, and I would go to Cedar Rapids to pick it up in a truck." He credits his business acumen to his father and notes that his father's suppliers Edward R. Schwinn and Frank V. Schwinn (the makers of Schwinn Bicycles) were among the first investors in Amana Refrigeration.

William Foerstner immortalized the early bicycles in a photograph in which two boys on a bike eclipse a horse and buggy — and a bygone era — on a gravel road twisting northward from High Amana toward Cedar Rapids. Foerstner's classic images of cars spilling over with kids and the Brunswick tire trucks coming to town offer a glimpse of other turn-of-the-century businesses. Foerstner also took pictures of his family and surroundings. He documented the barn fire in South Amana, where his brother Carl Foerstner lived. He took a panorama of gardeners from the second floor of the High Amana Church (now the Amana Arts Guild) and a lyrical pastoral of a shepherd surrounded by his flock. (East and West Amana — the most isolated and least photographed of the seven villages — kept the largest herds of sheep.) Often the early photographers gave negatives to the people in the pictures, and Amana photographer Clifford Trumpold rescued these last two negatives along with many others that he found at garage sales in the 1950s. The negative of the anonymous shepherd had so deteriorated that Trumpold experimented with a variety of intensifiers before recapturing the one-of-a-kind image.

Foerstner lived toward the end of a golden era in the Amanas, when frontier hardships were behind the Inspirationists and religious ardor still sustained most activities in the community. On a symbolic level, his pictures crystallize a collective consciousness of Amana in its own best image. True to his instinct as a businessman, however, Foerstner found a way to make commercial use of his hobby. He traveled the area as both a buyer and a manager for his stores, and took pictures of school groups, families, and even bank interiors. People in the surrounding towns hired him to take photographs. One picture shows a portable studio rig that he could set up even in a barn, and the ground glass of his view camera includes an oval area to be used for composing portraits to fit in oval frames.

In the years before he moved to the store and built his own darkroom, Foerstner developed his negatives with Middle Amana store clerk Charles Ruedy in Ruedy's darkroom. According to Trumpold, the two would have used wooden buckets to develop, fix, and

wash their negatives. Like other photographers of the era, they made prints by laying a negative on a sheet of light-sensitized paper and exposing it in the bright sunlight. Then the prints too would have been developed, fixed, and washed in the buckets, and laid out to dry. The resulting contact prints were the same size as the negatives used to make them—five by seven inches, four by six inches, and 3½ by 5½ inches.

More than three hundred of Foerstner's negatives fill the same boxes they came in—boxes of Hammer, Seed, and Cramer glass plates bearing the stamp of stores in Des Moines, Cedar Rapids and Chicago. The boxes stacked in baskets in the same attic where his camera and gear came to rest represent a profound document of life in the Amanas and in the small towns surrounding the colonies nearly one hundred years ago.

CHRISTIAN HERRMANN, 1890–1970

Though Christian Herrmann was a physician dealing with flesh-and-blood illnesses, his lyrical photographs reached at soulful revelations about life as expressed in everyday activities. The photograph of his mother carrying a basket of food through the snow is not only a compelling portrait of one individual but also an allegory reverently representing all mothers as saintly protectors and providers.

Herrmann started taking pictures in 1905, when he was fifteen years old. Over the next twenty-five years, he explored every possible venue of photography—family portraits and candids of Amana people at work, scenic landscapes, scientific images, travel photography, and a documentary of hospital conditions during World War I. According to his daughter, Ruth Schmieder, Herrmann "was interested in photography for artistic expression. He posed people very carefully, as you can see. They were not just random snapshots, but they were still so natural. He set it up like an art form." Schmieder, a renowned painter in the Amanas, lives in the Herrmann family home.

Herrmann also invited playful collaborations with the family and friends he photographed, and they can be seen miming for the camera. While Bertha Shambaugh could share Amana's kindly but reserved image of itself in her photographs, Herrmann, because he was an insider, was able to capture the joyful caprice bursting from just behind the solemnity communicated to the outside world—and to the elders. He combined mirthful

camaraderie and a poetic arrangement of his subjects, even in what might have been a mundane snapshot of the young women who had just finished cleaning his father's medical office in Middle Amana. For a final signature, Herrmann jumps into another frame of this shot, throwing an insouciant sideways glance as though he is quite unaware of what is going on.

The kindly, courtly Herrmann served the Amanas as a physician for more than fifty years from the office adjacent to his home in Middle Amana. The party celebrating his fiftieth anniversary as a doctor expressed the outpouring of love and appreciation people felt for him. He had delivered two thousand babies over the years, and dozens of guests at the party commemorated his services with buttons that said, "I am a Christian Herrmann baby."

Herrmann's father, also named Christian, had trained as a community blacksmith until the elders decided he had the makings of a doctor and sent him to medical school. Sons frequently followed in their father's professions in the Amanas, and Herrmann agreed to study medicine too. In preparation, he attended high school in nearby Marengo. He started taking photographs during high school with a view camera, probably encouraged by his brother-in-law, F. William Miller, who had been photographing for several years by then.

Herrmann graduated from high school in 1908 and continued on to medical school at the University of Iowa, where he took film negatives with a more portable Kodak camera that would become his travel camera. He photographed Iowa City, his classes, and the gymnastics team (of which he was captain). He graduated in 1915 and left Iowa to intern in Montreal, Canada. En route, he photographed the lakefront in Chicago and the famous monuments in Washington, D.C. He carefully spliced together three images of George Washington's Mount Vernon estate to create a panorama. Montreal provided him with ample opportunities for new shots as well. The photographs of hospital scenes from Herrmann's internship at Montreal General Hospital offer a rare view of medical practices during the era of World War I. He documented the rows of patients in airy rooms with open windows, ceiling fans, and sunlight pouring in, and photographed groups of doctors and nurses, poetically grouped in compositions reminiscent of those he took of people working in the Amanas.

Herrmann returned home in 1916. Johanna Jeck, barely a teenager when he left for the University of Iowa, was now a striking, lithe young woman with a classic face and large

blue eyes. She was an agile ice skater—a talent that appealed to the athletic Herrmann. In winter, ice skaters could travel for miles across the Amanas on the Iowa River. Johanna and Christian fell in love ice skating and began dating seriously. They were engaged by the time Herrmann became a lieutenant in the U.S. Army during World War I.

Herrmann was sent to Fort Pike in Arkansas to oversee the pneumonia ward during the dreadful winter and spring of the 1918 influenza epidemic. He kept a journal of his medical work and photographed in the mountainous terrain surrounding the fort. The contrast in these two records of his experience is heart-wrenching. The journal records an idealistic young physician's confrontation with an unremitting cycle of suffering and death. In a day before antibiotics, treatment of pneumonia amounted to a twenty-four-hour vigil at a patient's bedside, with cold packs for fever, liquids to drink, and prayers for a miracle. "Altogether there were eight deaths today while I was on duty and, in several cases, I had to speak to the relatives. It was tough," he wrote on Oct. 4, 1918. "Just before I went to supper, they sent me ten cases, filling my ward to capacity, every bed filled. As quickly as one man died, another would be put in the bed." He recounts the rest of an arduous, horrifying night, when the numbers in the ward rose so rapidly that both corpses and new patients lay on the floor. By contrast, the primeval landscapes Herrmann photographed emphasize powerful, sweeping vistas, and almost abstract close-ups appear rugged, invulnerable, and eternal.

In February 1919, with the war over, the Amana Society intervened to win Herrmann and others an immediate honorable discharge from the military so they could return to duties at home. Herrmann had referred in his journal to letters and parcels from "my girl"; Johanna had waited for him, and the two were married later in the year. During their courtship, Herrmann had taken typically romantic photographs of Johanna. Now that they could be at home together, he took a picture of his young wife sitting in a rocking chair in full Amana dress, a huge volume open in her lap, and her feet clad in black high-top shoes propped on the stove. In an age of photographic artifice, the picture epitomizes Herrmann's eye for elegant composition found in the simple grace of life. His portrait of his sister, Helene Herrmann Miller, as she casts her fishing line carries the same combination of formal composition and appreciation of natural form. He continued to photograph pastoral landscapes and abstract close-ups as well. While other photographers photographed trains and train wrecks, he photographed the rails as symbolic veins to another world.

In a lined notebook, Herrmann recorded negative numbers, dates, and details about each of his photographs with true scientific precision. His pictures of medical situations contrast sharply in their clinical bluntness with his other work. He shows the ravages of tumors, pellagra, and trauma. He took his first medical images as a teenager in his father's office, photographing a 1907 demonstration of a special table used to set hip fractures. Hermann was a photographer who captured and eloquently expressed the dimensions of human vulnerability.

PAUL KELLENBERGER, 1909– , AND RUDOLPH KELLENBERGER, 1907–1996

Emil Kellenberger came from Switzerland and settled with his wife, Clara Schoenfelder, in West Amana, where they had nine children—three daughters followed by six sons, including photographers Rudolph (Rudy) and Paul Kellenberger. Rudy, the more entrepreneurial of the pair, ordered magazines and notions wholesale and sold them in the Amanas. Paul, the more scholarly, walked the five miles to Marengo to take out books with his Marengo library card.

An elder, noticing his studious inclination, convinced Paul to become a teacher. "I did not want to become a teacher," Kellenberger recalls. "My father died in November 1922, and then, when I graduated in the spring of 1923, I still remember very clearly going to see the chief elder in West Amana, Carl Geiger. He called me to his house and talked to me for several hours about [becoming] a teacher." He was sent to East Amana to study while he took high school correspondence courses from the University of Chicago and then attended Williamsburg High School, since Amana did not have a high school as yet. He graduated in 1927 with a teaching certificate authorizing him to teach at any public school in the state, and began his career in the West Amana school in the fall of that year.

While Paul was away, Rudy took up photography and bought an Eastman Kodak No. 2a Brownie box camera for three dollars. His pictures comprise the first sustained documentary of the Amanas made exclusively on film rather than glass plate negatives. Glass plate photography had survived as the superior product for serious photographers for forty years after the introduction of film photography. But as the 1920s ushered in the hey-

day of photojournalism, behemoth view cameras and glass plates became dinosaurs. Erma Schanz Kellenberger, who had been married to Rudy Kellenberger almost sixty-three years when he died in 1996, remembers that he "always had the camera when something was going on. He'd take it to work with him, and if they were building a house somewhere, he'd take pictures of it."

When Rudy Kellenberger met Erma in the 1920s, he was working in the horse barns. He talked to the mares Queen and Nellie "just like you and I are talking now," Erma laughs. Even the stallions respected and obeyed him, and he could walk them to water across a pasture of spring grass without fear that they would run away from him to graze. Horses figure prominently in Kellenberger's photographs: horses as a driver might see them from the wagon seat, horses hauling ice and timber, and horses standing in the twilight of their reign as the tractor takes control for mowing hay. The pictures fondly glorify animal and human partnerships by sharply delineating forms at work or simplifying them into commanding compositions in silhouette. Kellenberger also loved to photograph visual curiosities and illusions. The mythical being emerging from the Amana lily pond like a lost spirit is really his brother, Paul, harvesting the flowers.

Like William Foerstner, Kellenberger posed his own wedding picture and handed the camera to Paul to snap the picture, taken at street level because the society elders no longer controlled photography. Rudy and Erma Kellenberger's 1933 wedding picture is a loving, personal memoir that poignantly represents the collision of past and present shortly after the reorganization in Amana. He wears a light, modern suit that would blend in anywhere in the 1930s, but Erma wears traditional Amana wedding attire—an apron and cap modestly covering an Amana print dress in a modern cut. The couple, with their Bibles and serious expressions, recall a bygone time, but Rudy's arm firmly around Erma evidences a new era, when couples could openly embrace. They married the year after the Change. Rudy Kellenberger documented the upheaval caused by the reorganization with photographs of auctions at the Amana Society communal kitchens of wares that were no longer needed. He pulled far enough away from the action to capture the crowd and confusion of objects at an entertaining event with deep undercurrents of loss and uncertainty.

Rudy and Erma settled in Erma's family home and raised their family there. Paul, still a bachelor, lived with his mother in the Kellenberger family home. He had helped lead the Change as one of the Committee of Forty-seven that decided the fate of the old Amanas.

Paul Kellenberger was one of the few members who would have preferred a revival of old spiritual values rather than the transition to a private-enterprise economy. Now he took up photography too and documented the timeless beauty of the Amana lands along with many other subjects that fascinated him. His five thick albums include rare photographs of the interior of the West Amana Church and other structures that closed as Amana's communal era ended. But rather than dwell on the past, Paul Kellenberger documented the spirited, headlong rush of a nineteenth-century society into the jazz age. His pictures show sunbathers lounging on the Iowa River, Maifests with a Bavarian flair, sports teams, plays, and Boy Scout troops. Kellenberger was one of the first leaders of the Amana Boy Scouts, and he photographed the regional camp gatherings of troops from across Iowa.

By the mid-1940s, he was photographing the Amana boys in another uniform, as he and many others headed off to serve in World War II. Despite the community's religious belief in pacifism, Amana residents had enlisted for wartime service since the Civil War. After a stint in basic training at Camp Carson in Colorado, Kellenberger was assigned to a medical unit in New Guinea and had his camera in tow, of course. Other GIs offered to pay him to take pictures for them and of them. So started the Kellenbergers' World War II photography business with a flood of images from wartime New Guinea and the Philippines that Paul sent back to Rudy in West Amana, Iowa. Paul took landscapes, tourist shots, camp pictures, and portraits of soldiers and their friends. He sent all the film to Rudy, who kept the negatives and sent proofs to Paul. Paul posted the pictures, took orders by proof number, and sent the orders back to Rudy to be filled with four-cent commercial reprints that the brothers sold for ten cents.

Paul Kellenberger found the return to Amana difficult after the war. "Those fellows in my tent said that the army changes people, and it had changed me. I had served in the war for three and a half years, and now here I was in this tiny little village," Kellenberger recalls. "All my life I went to school either as a student or a teacher, so I went back to the University of Iowa on the GI Bill." He studied statistics and then resettled in Chicago, where he worked for an insurance company and married in 1950. Paul and Martha Kellenberger live in a suburb of Chicago.

Aside from the Amana albums that he sent back to his nephew in the colonies, Paul Kellenberger's albums of other subjects stand in two waist-high stacks in his living room.

Both he and Rudy photographed for more than sixty years, creating a visual chronicle not just of the Amanas but of the fabric of life throughout much of the twentieth century.

F. WILLIAM MILLER, 1876–1952

F. William Miller grew up in a house near the Amana hotel, where visitors such as the Horack family and traveling salesmen stayed. Miller was fourteen when Bertha Horack started her photography project of the Amanas. Miller and Bertha's younger brothers, Claude and Frank, cemented lifelong friendships during the family stays in Amana each summer. They fished together on the Iowa River as boys and continued to visit each other until later in life, when Claude Horack, a Harvard graduate, became dean of the law school at Duke University in North Carolina.

Miller's future was uncertain when he followed the lead of his older brothers and left the colonies at about age fifteen. He was the great-grandson of Christian Metz, the charismatic Werkzeug who had led the Inspirationists to the United States, but he decided he could find more opportunities "outside." He took a job as caretaker of the Grace Episcopal Church in Cedar Rapids and served as a driver for the minister. The minister offered to send him to high school and college in exchange for his services. With the sudden death of his father, however, he returned home in answer to his mother's pleas. "My grandmother wanted him back," his daughter, Louise Miller DuVal, explains, "because he was the one she relied on most. So he returned and worked on the farms and in the woolen mills in Amana." Subsequently, the elders assigned him to work as a driver and helper for Dr. William Moershel, Sr. Though Miller was only twenty years old, he kept the medical supplies in order, drove the horse and buggy on house calls, sometimes assisted in home surgeries, and did a lot of fishing with his new friend and mentor, the doctor.

Miller wrote a day-by-day diary of those years (1896–1898) in a thick, leather-bound journal. The words provide as vivid and compassionate a picture of country medical practice and Amana life as any of the photographs Miller began taking at the turn of the century. The first several months of entries detail weather conditions nearly every day—a poignant reminder of how muddy roads and snowstorms made the difference between life and death as Miller drove the doctor to the various Amana villages or to a farmhouse sev-

eral miles beyond. The Amana doctors and pharmacists served the farm families throughout the region, and Miller began to describe in his journal rides in the predawn chill to faraway patients who might already be dead. He reports that they found out about the death of a man kicked by a runaway horse while en route to the house and turned back. He gave ether to a patient during surgery, he noted in a March 1897 passage: "We had no dinner and felt pretty hungry [on the way home from the surgery]. So the doctor went into a farmhouse and bought some lunch consisting of bread and butter."[3]

He interspersed the medical cases with descriptions of fishing conditions and threw in an occasional measure of gossip here and there. His accounts of the fun of fishing and hunting expeditions with Dr. Moershel suggest that there was a close camaraderie between the two. Moershel most likely recommended to the elders that his bright and capable helper should be sent to study pharmacy so that an additional pharmacy could be established in Homestead near the doctor's medical office. (At the time, the only pharmacy in the colonies was in Amana.) Miller's journal stops with his departure to the University of Iowa.

Miller began to record a new kind of journal in photographs in the late 1890s, taking some of the earliest photographs attributed to an Amana photographer. According to DuVal, Shambaugh influenced his interest in photography and continued to visit him in the Amanas, taking the formal 1901 portrait of him in his pharmacy, where, in addition to filling prescriptions, he sold popular hand lotion and hog remedies that he had concocted. His choice of subject matter differed markedly from hers. There was no newspaper in the Amanas, but Miller documented car and train wrecks with the instincts of a photojournalist. At a 1905 train wreck caused by sabotage, he set his camera aside to comfort the badly scalded engineer as he died at the scene. The man was already in shock and shivering, despite his burns, when Miller and Dr. Moershel reached him; the doctor was able, however, to save several other victims with a disaster kit of medicines and supplies he kept on hand for such emergencies. Miller also photographed the disastrous Rock Island wreck in 1912, car by car. The toppled engine resembled some great fallen beast, with the railroad inspector standing in front of it like a conquering hunter.

He extensively photographed the ruins of the woolen and flour mills in Amana in the aftermath of the 1923 fire. The burnt-out skeleton of the mills calls to mind ancient ruins in a haunting series of unpeopled images. For all his personal work, he recorded the f-stop,

shutter speed, subject, date, and light conditions on the negative sleeve of each shot with the precision of a professional accustomed to labeling prescription medications. The sleeves indicate he was photographing with a Korona view camera, the same type of camera that William Foerstner used.

During this period, Miller also began photographing German aliens working in the Amanas, a commission from the government. His assignment was undoubtedly suggested by Shambaugh, who had written a labor report on the Amanas in 1905 for the Iowa Department of Labor. Miller worked in a home darkroom below the pharmacy, where he had built a sink and fitted it with trays and chemicals, and printed all his work on popular postcard stock with a preprinted postcard label on the back. DuVal speculates that the Amana Society may have sold his cards in its stores, providing him with photographic materials in exchange. She has hunted down the postcards and purchased them back at dozens of card and antique shows.

Miller also made a powerful body of personal work centered on his own wife and children, and the extended Miller and Herrmann families. The eligible Homestead pharmacist, already nearly thirty years old, began courting Helene Herrmann about 1905. Miller took a picture of himself and fellow swains Otto Eichacker and John Kippenhan aboard a railroad handcar that they would borrow to go courting on Sunday afternoons. They would position the handcar on the Chicago, Rock Island, and Pacific rails and head out of the Homestead depot to the "cut," where the Chicago, Milwaukee, and St. Paul railroad tracks tunneled under the path of the Rock Island line. From there, Miller would walk to Middle Amana, fording the small bridge across the Iowa River, while his friends continued on in the handcar toward Amana. "Of course, since Otto was the depot agent in Homestead at the time, he knew the train schedules by heart," notes DuVal. "They knew exactly what time they could leave Homestead and get to Amana without running into any trains along the way. I can just see the three of them hauling this heavy handcar off the one set of tracks, down the grade onto the other set of tracks." All three fellows married the sweethearts they courted on those trips. Soon Helene's brother Christian began taking photographs too, and throughout the coming years he and Miller would create a chronicle of strong and poetic environmental portraits.

Unlike many of the historic pictures taken of the Amanas, Miller's most famous transcends time and place. "Schulwald" (school forest) shows his two children walking through

a pine forest that leads to the schoolhouse in Amana. Miller helped plant the forest when he was a schoolboy in Amana. The picture is often cropped, but viewed in the full frame, two huge tree trunks anchor the foreground like pillars holding up the sky. Feathery patches of light dapple the pathway as the children walk through the trees toward a small passageway of brilliant sunlight in the distance. The trees resemble guardian sentinels hovering protectively over the two tiny figures passing at their feet. The image is an epiphany of summer and childhood taken by a prolific photographer at his very best.

WILLIAM F. NOÉ, 1898–1978

William F. Noé fits the mold of a Renaissance man. He started out working as a clerk in the Amana general store in the 1920s and opened one of the first antique shops in town, Tick-Tock Antiques, nearly five decades later. A career as one of Amana's most trusted leaders filled the years in between. Noé combined practical business acumen with deep spirituality and a sentimental sense of Amana history. He served as an elder in the Amana church for twenty-nine years but also helped reorganize the society into one where businesses, civic institutions, and the church itself operated separately and successfully. He took correspondence courses in business from the La Salle University's extension division and became treasurer of the Amana Society after the Change. He wrote crossword puzzles for the *Chicago Daily News*, played the zither accompanied by brother John's violin, wired his house for electricity in the 1930s, and repaired clocks. He grafted new varieties of apples and built a stonework fence to landscape the yard for his wife's garden. He was a jack-of-all-trades and even painted for awhile, like his brother John Noé, who remains one of the most revered painters of the Amana Colonies. William Noé's paintings celebrated Amana buildings and explored the artistry of shadows, subjects established long before in his documentary photographs of the Amanas.

Noé began taking photographs in the 1930s and over the next thirty years took hundreds of pictures. His cameras included a Graphlex, the cumbersome 1940s classic for press photography. He carefully filed each negative by village and by subject, including people, furnishings, farmlands, automobiles, and dozens of other categories. "I can remember going hunting for grasshoppers with him. He'd set them up and make scenes with

them to photograph," recalls his daughter, Marie Noé Larew. "He had a homemade enlarger and his darkroom was Mother's [Ida Hertel Noé's] kitchen. He was always taking pictures for people, and he did a lot of work with different kinds of lighting." His photographs show him experimenting with lighting to create dramatic backlit silhouettes and to cast shadows, as exemplified in a dramatic still life of eyeglasses set on an open Bible. He used professional retouching techniques, such as highlighting details of photographs with black pencil—a technique called opaquing—on some of his original prints.

Amateurs continued to use popular Brownie cameras, and amateurs and photojournalists alike popularized 35 mm cameras during the time Noé was photographing. Even though he never used glass plates, Noé still loaded each 3½-by-5-inch negative separately in a film holder for the Graphlex. Like Noé, purists and many commercial pros preferred larger negatives for superior clarity in enlargements. Later, he bought a more compact camera, the German-made Ikoflex, which used roll film and made 2¼-inch-square negatives.

Noé's professional approach to photography filled an essential role in Amana after the Change. When the colonies needed pictures for brochures and other materials, Noé often took them. According to Larew, "he did a lot of pictures for the Amana Society. He wanted to help." He sent pictures to the *Des Moines Register* and the *Cedar Rapids Gazette*. Noé provided the Amana Colonies with the community's first professional publicity photographs, though he would have shied away from any such description of his work. "He was uncomfortable with the concept of marketing. He never would have wanted to 'show off.' There was a dignity and serenity about him," notes Emilie Hoppe, editor of the Amana publication *Wilkommen*, adding that "I think of him as my grandfather." Hoppe is a granddaughter of Noé's second wife, Louise Wendler Noé, whom he married in 1971, a few years after Ida's death.

Noé approached photography, as everything else, with a deep commitment and a clear personal dedication. The number of photographs he took and his careful system of filing them create an encyclopedic chronicle resulting from one man's fervent race to preserve the past. In one long-running series of images, he documented Amana's artisans—broom makers, toy makers, and wheel makers. Though he took the pictures indoors, he relied on the soft, luminous play of natural light, a kind of dusk light of memory or nostalgia. He made powerful portraits of the elderly Inspirationists, sharply delineating the wrinkles and furrows that linked them to the past. He also photographed the inner workings of the

woolen mills and made an architectural survey of many of the buildings in the villages. Not all the pictures he took allowed him to be so expressive. He photographed dozens of items of Amana furniture for catalogs. Like any pro, he took whatever picture the job called for with technical precision. Yet Noé continued with his full-time job as Amana treasurer all the while he was taking the photographs. Even in retirement, he ran Tick-Tock Antiques with Louise Noé. "I can't ever remember him just sitting," reflects Larew.

Noé's photographs continue to be reprinted in magazines and books, on postcards, and as wall murals that often hang in rooms with his brother's paintings. Because of his love of photography and Amana heritage, other families entrusted photographs to him, including the family of photographer Fred Oehl, Sr. Noé preserved Oehl's priceless turn-of-the-century glass plate negatives. Both the Noé and Oehl photographic collections are at the Museum of Amana History, just down the street from Noé's family home. He and his family lived in one of two adjoining residences; his brother John and John's family lived in the other. Their father, John Noé, Sr., who was treasurer of the colonies before the Change, had taken some photographs, placing him among the earlier generation of Amana photographers. Their grandfather William Noé had been one of the four members of the Inspirationists sent to the United States to find a safe home for the community that William F. Noé served so long and so well.

FRIEDRICH OEHL, SR., 1866–1946

Fred Oehl loved gadgets. He had the first phonograph in the Amanas and put together the first crystal set—an early radio receiver. He taught himself to repair sewing machines and clocks and to recane chairs. He was a carpenter, a job that often encompassed the skills of an architect and engineer, and he was given responsibility for rebuilding the Amana woolen mills after the 1923 fire. Oehl doubled as an Amana salesman, driving the society's Model T Ford down country roads and into nearby towns to sell Amana products and cream separators made by Iowa Manufacturers, one of several distributorships operated by the Amanas. Oehl's good friend, pharmacist F. William Miller, sometimes accompanied him and sold the popular hand lotion and hog remedies he had concocted.

On one of these forays, his daughter Elizabeth Wetjen suggests, Oehl probably bought

his view camera secondhand. Like all gadgets, the camera fascinated him. He and Miller were among the first photographers to follow Bertha Shambaugh's lead and take pictures inside the Amanas. Oehl's photographs date from 1900, when he took pictures of his infant daughter Magdelena, who was born that year, ten years before Elizabeth. Owning cameras was discouraged by Amana's leaders, but that did not bother Oehl. "When [the elders] found out he had one, he wasn't allowed to go to church for several weeks. He was supposed to get rid of it. But I don't think he did. He was a rebel," Wetjen reports. His dog and phonograph were frowned upon as well and also brought sentences of expulsion from church, all to little avail. "If it was forbidden, you could be sure he had it," his daughter laughs.

Oehl took an early 1900s picture of people from throughout the colonies gathering in Amana on Holy Thursday for the Liebesmahl (communion service), which was held every other year at that time. The unique photograph was taken from an upstairs window of the Amana school, now part of the Museum of Amana History. Typical of Oehl's style, the picture is a tapestry of activity, as horses, buggies, and people converge for services, and the women walk in single file just below the vantage point of the camera. The scene marks the busiest tourist stretch in modern-day Amana, where many of the houses lining the plank sidewalk shown in the picture are now restaurants and stores.

Undaunted by his big camera and breakable negatives, Oehl also climbed the bell tower for other views of the town as a hive of activity. Vistas from on high, which have always attracted photographers, offered particular appeal in Amana, where the elders tried to prohibit the camera. Regardless of the reason such pictures were taken, they convey a distinguishing characteristic of Amana as a self-contained world and synthesized generations of Amana history at a moment when the old ways were fading. "As I see it, the beginning of the Amana transition was about the year 1900 with the advent of the automobile. People came to the Amanas with their cars and took pictures" and, Carl Oehl suggests Amana people wanted to do the same. Carl Oehl, who lives in the family home, speculates that his grandfather and several of the other photographers in town may have had a camera club or at least shared manuals and their own trial-and-error efforts at learning photography.

The nearly two hundred of Oehl's glass plate negatives that remain at the Museum of Amana History attest to his interest in experimenting with photography. His film was too

slow for "stop-action" shots, but he still managed to capture motion shots, such as a dramatic panorama of a steam locomotive chugging across a bridge. He became the first Amana photographer to take pictures of the haunting weather-worn buildings that had been abandoned in Ebenezer, which he visited on a trip to New York in 1901.

Oehl loved to photograph "characters," such as Piestengel Paul, one of the itinerant workers hired by the Amanas. The workers typically had nicknames that referred to distinguishing traits—in this case, Paul's taste for piestengle (rhubarb) wine. Paul cut a dashing figure, and Oehl captured a genteel portrait of him smoking his ornate pipe and reading a newspaper. Oehl stopped workers, even those clearing a train wreck, to get a dignified "formal" portrait amid the catastrophic scene.

Oehl also had a special talent for photographing children. He married Louise Roemig in 1891, and, as the father of seven, he had plenty of subject matter. In addition to posed shots, he captured the cacophony of childhood activities, even a tantrum that erupts while the "Oma" looks on benevolently from the distance, like a guardian angel. If there was a railroad wreck or a flood in town, he took the kids to see it and posed them for a photograph. According to Wetjen, Oehl loved doing things with his children. He loaded them into the Model T as he made the rounds to sell the cream separators. He taught them chess and checkers and lots of card games, and filled the house with books because he felt people could teach themselves anything from books. "He bought an algebra book for a few pennies when he got out of the Amana school and taught himself algebra," Wetjen laughs. "He got me a piano and some books, and I was supposed to teach myself piano. But I just couldn't do that."

Oehl also took the children into his darkroom to watch the pictures magically appear in the glass plate negatives. The combination darkroom–wine cellar in the basement was the one place the children were not allowed to go alone. According to Carl Oehl, his grandfather stopped taking photographs later in life. He gave lots of his negatives to the families pictured in them and placed those he wanted to keep in brown paper sleeves with handwritten dates and descriptions of their contents on many of the sleeves. Oehl brought a sense of humor to the labels as well as the pictures. One glass plate negative of itinerant workers shows three inebriated fellows leaning sideways. Among the notes on the sleeve, Oehl wrote: "_____, _____, _____—windy," even though the workers are sitting inside and are leaning for reasons other than the weather.

Among the many stories they tell, Jacob Selzer's photographs recount a triumph of the human spirit. He took some of the most humorous pictures in the Amanas, even though he was dying of tuberculosis at the time. After his death, his wife, Henrietta, learned how to use his camera and darkroom, where she developed sylvan pictures of their children. Henrietta's daughter, Barbara Selzer Yambura, has immortalized her mother's spunky independence in *A Change and a Parting*, her memoir of growing up in the Amanas.

Jacob Selzer worked in the Homestead store after graduating from eighth grade but left the Amanas in October 1907 and got a job in the arsenal in Rock Island, Illinois. On visits home to Homestead, he began courting Henrietta Geiger. They planned to marry, but the Amana elders opposed the marriage because he had contracted tuberculosis. The highly contagious bacterial disease was easily spread by the sufferers' incessant coughing in the poorly ventilated factories and warehouses of the day. The young couple refused to back down, however, and married on April 2, 1914. Selzer had returned to Amana by then, the best place to be, since fresh air offered the only possible hope for remission of his illness. He took over the harness and saddle-making shop in Homestead.

The young couple was surrounded by family. They lived with Henrietta's father, Philip Geiger. (Her mother, also named Henrietta, had died in 1894.) Jacob's parents and his brother all lived within a few blocks of them. Jacob Selzer had purchased a camera and began shooting glass plate negatives that he printed on postcard stock. Amana work scenes were a favorite subject, and these are his best-known contributions to Amana history. Aesthetically, the pictures have a look all their own. Selzer would fill the frame of a photograph with a mosaic of activity that pulls the eye in all directions. He photographed arresting textural patterns inherent in ordinary landscapes: rows of houses down Homestead's main street or piles of lumber in the timber in winter, when the trees were as bare as the sawed logs. People blend into the graphic balance of the image rather than becoming primary subjects.

Even in illness, Selzer could laugh at the world and invite the world to laugh with him by photographing funny, quirky tableaux. He dressed up the dogs and cast them in human situations for some pictures. His shot of the great hunt shows a gun and game hanging from a tree stump with a small, timid spaniel posed on the stump—hardly the proud,

conquering canine expected for such a scene. Selzer's brother shows off like a circus performer, riding astride two horses and brandishing his whip in another picture. In still another, his family poses in a horse and buggy, magically riding through an overgrown, storybook forest without a road in sight.

Selzer took these light-hearted pictures as his tuberculosis was spreading rapidly. The colonies sent him to the nearby Oakdale Sanitarium, a rest home devoted to tuberculosis. Such places, immortalized in Thomas Mann's masterpiece *The Magic Mountain*, dotted the Americas and Europe. Tuberculosis, called "consumption" at the time, was a leading cause of death throughout the world, bringing almost certain death once it had spread beyond the lungs to infect other organs or bone marrow. Selzer was only twenty-eight years old when he died in 1917. He and Henrietta Selzer had been married just three years and had two small children. But Henrietta had her father and in-laws to help her and the cradle-to-grave security of the Amana Colonies to depend on.

Yambura's book paints a picture of Henrietta Selzer as a brave and decorous young widow, who saved carefully from her ration book and sold needlework and produce to afford extras for the children, such as the pair of black patent leather-trimmed shoes Barbara wanted and the rare luxury of a white porcelain bathtub, among the first in the Amanas. She kept all the family heirlooms that antique seekers were constantly offering to buy at a fraction of their value. According to Yambura, she kept Jacob's camera as well and started taking pictures with it. The pictures left behind the loveliest possible memorial to their marriage.

Henrietta Selzer is the only woman in the Amanas known to have taught herself photography with the old view cameras and glass plate negatives. Though she photographed with Victorian equipment, she worked a generation after Bertha Shambaugh, and the world had changed. World War I had shattered the norms of Victorian dress and behavior and ushered in the roaring twenties. Life went on as usual in the Amanas, but the colonies were feeling economic pressures for the first time and lots of young people were leaving.

Selzer, however, ignored both the Amanas and the outside world in her idyllic photographs. She concentrated on one subject—the children—and carted them to forests, a stone drainage tunnel, and the riverfront, where she set up her camera and tripod. "We did a lot of things together," Yambura recalls. "We used to take walks in the forest to pick mushrooms. . . . I remember being with her in the darkroom and seeing those pictures

magically appear" on the postcard stock Henrietta used. Henrietta's nephew, Art Selzer, who lives in Homestead near Henrietta's family home, also remembers her "taking pictures when we were kids." The "kids" in the pictures are the four young heroes in Barbara Selzer Yambura's *A Change and a Parting*. Although she has given them fictional names in the memoir, Art Selzer is one of them, along with Yambura and their brothers. The sylvan children posed amidst ferns, flowers, and trees in Henrietta Selzer's pictures bear little resemblance to the mischievous crew of cousins who, Yambura reports, burned a smelly skunk carcass in their aunt's new stove after trapping it and skinning it for its $2 pelt.[4] Instead of taking images that documented the time and place of her excursions, Selzer chose to wrap the children in timeless, pastoral backdrops.

PETER STUCK, 1890—1979

Peter Stuck helped lead the Amanas through the crisis of the 1932 reorganization that separated the church and the economy in the colonies and placed property in private hands. He sat on the porch of the Amana Society main office with William F. Noé the day of the vote on the proposal directing the reorganization. He knew everyone who came to cast a ballot and had taught many of them in the Amana school. Nearly eighty percent of the people voted in favor of the Change—a great victory for a man who had known devastating personal losses. His lovely bride, Louise Moershel Stuck, died from complications of childbirth within a year after their marriage in 1914. Stuck never remarried. He raised his infant daughter, Marie, with the help of her four grandparents, since he was teaching every day. Then Stuck had to give up his profession—a rare occurrence in Amana—because of a throat ailment that left the proud, stoic man unable to speak audibly. Slowly, he regained his voice, but a new teacher had been assigned to the school, so Stuck became assistant postmaster in Amana instead.

The former teacher taught himself photography, although perhaps with some assistance from friends such as John Eichacker, an amateur photographer who also served on the committee that drafted the reorganization proposal. Stuck's photographs express a precision, creativity, and introspective solace that could transcend the hard blows of life. His earliest work on glass plate negatives includes a sculptural series of still lifes of flowers,

milkweed, and even simple grasses. He composed each shot full frame, moving in for extreme close-ups of flowers spilling across their stems like pearls, or milkweed bleeding its pods. Stuck explored unique backdrops for the work, using crumpled paper as a textured backdrop for carefully arranged blades of dried grasses that alone would have made for a rather meager picture.

Stuck purchased glass plates from the Seed Dry Plate Company and Ansco Company at ninety cents for a box of a dozen and used them as late as 1930. He also began to take film negatives on a Kodak No. 1a pocket camera. He created studio setups for portraits such as one of a modern 1920s Amana high-school girl with bobbed hair and a middy blouse. His photographs of activities in the Amanas often bear an impressionistic, painterly style, best exemplified by a shot of men fishing with their web of nets. A journal Stuck kept in 1928 provides a running account of his photographic activities, which he clearly approached in the unassuming but dedicated manner that he brought to everything he did. "Received this morning a portrait attachment for my camera or Kodak. It cost me 65 cents," he wrote in a January entry. "Snapped pictures today—interior of the lumber office and two interiors of blacksmith shop. Developed film and pictures seem to [have] come out good," he wrote in March, one of several such entries.

Stuck wrote about photography for publication as well, submitting a freelance article, "Take your Own Picture at Leisure," to an unrecorded publication. "The accompanying portrait of myself," he writes, "was taken by me with the help of a fair-sized mirror, indoors, about three feet from the east window at noon on a bright sunny day in March. The exposure was five seconds with the stop opening at f.11. When making the print, I used a mask to eliminate the frame and beveled edge of the mirror . . . so that the finished picture showed hardly any trace of the method of how it was procured."

When Amana elected representatives from each village to decide the fate of the colonies, Stuck's life took a permanent turn. He was secretary of the committee for which John Eichacker was chairman and F. William Miller vice chairman. Noé, Christian Herrmann, and Paul Kellenberger were also on the committee. Stuck helped write the articles that reestablished the colonies as a corporation with society members as the sole stockholders. He valiantly defended the new system against uninformed critics in the press who blamed him and the other leaders of the society for eliminating the old communal ways. Stuck was elected the secretary of the Amana Society after the Change and served in the

post until he retired in 1968. Later in life, he moved in with his daughter and son-in-law, Marie and Art Selzer, in Homestead. When the family closed down his home near the Museum of Amana History, they discovered the extensive collection of Selzer's own photographs and the photographs of others that he had preserved, and realized that he had saved an archival treasure trove of papers and other materials concerning Amana history.

F. William Miller.
"Schulwald" (School Forest), Amana. Miller helped plant the pine forest in
Amana as a schoolboy and posed his two children there on October 1, 1916.
Collection of Alan and Louise Miller DuVal.

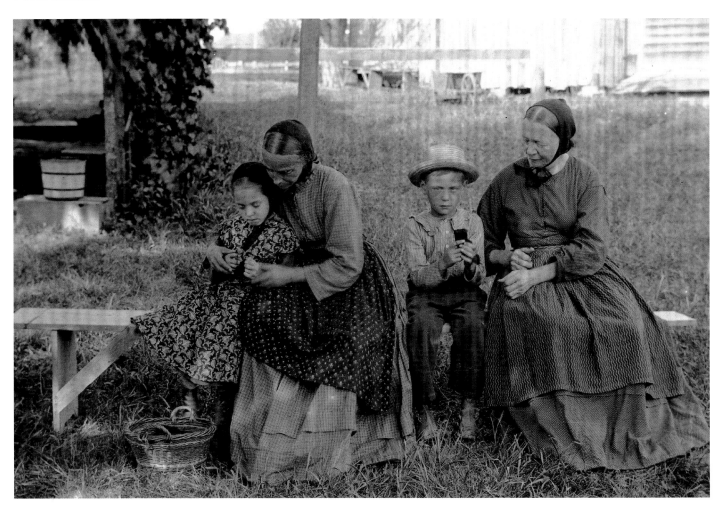

Bertha Shambaugh.
"The Knitting Lesson,"
Amana, ca. 1898.
Private collection.

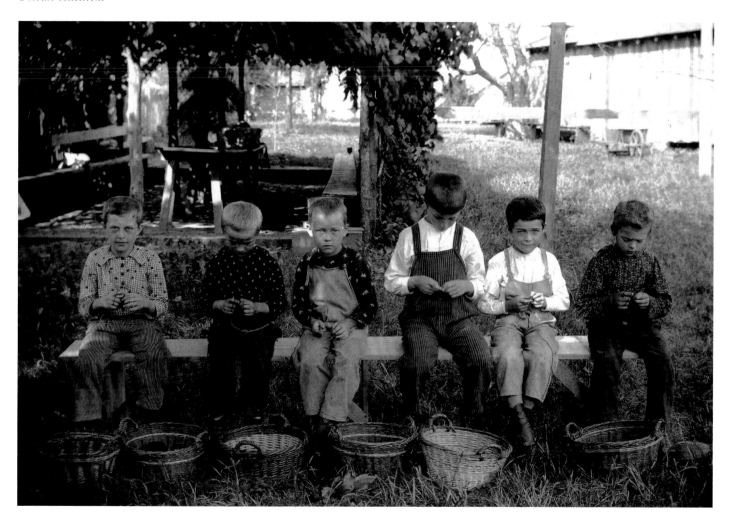

Bertha Shambaugh.
Amana orchard, ca. 1890s.
Private collection.

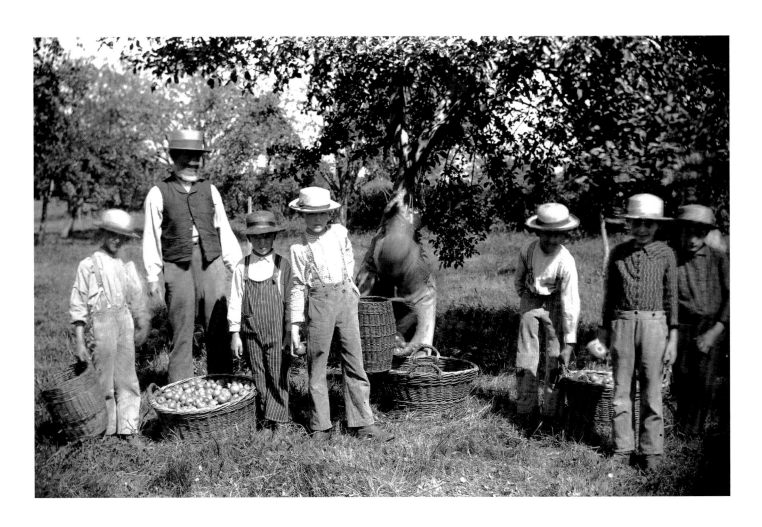

Bertha Shambaugh.
"Ring Around the Rosie,"
Amana, ca. 1890s.
Private collection.

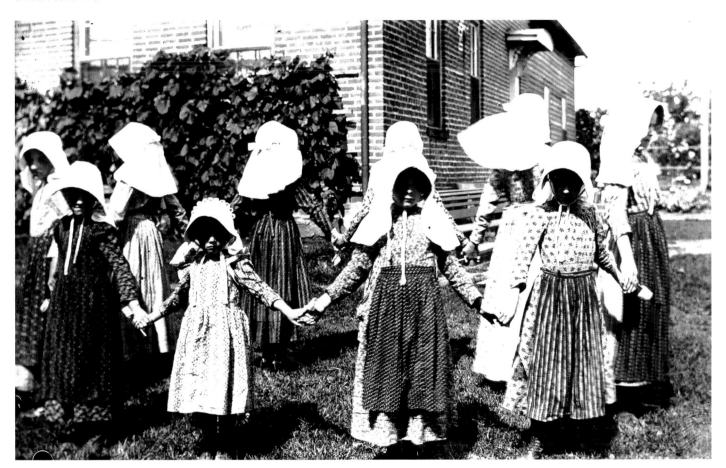

Bertha Shambaugh.
"London Bridges Falling Down,"
Amana, ca. 1898.
Private collection.

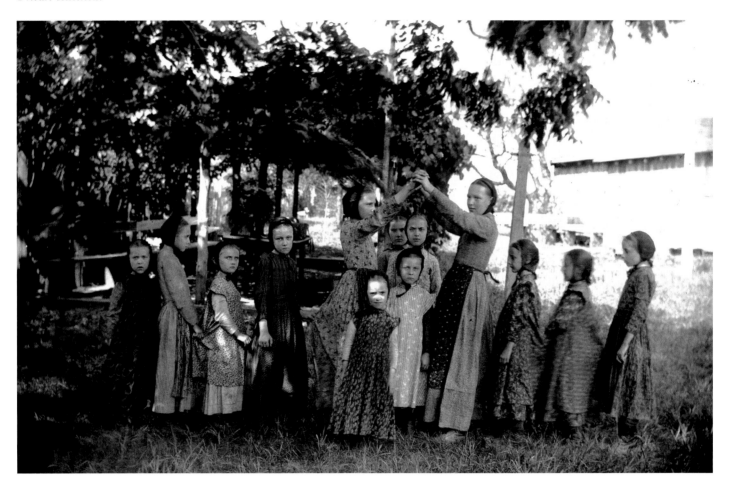

F. William Miller.
Amana school boys testing seed corn, Amana, 1918.
Museum of Amana History, gift of Alan and Louise Miller DuVal.

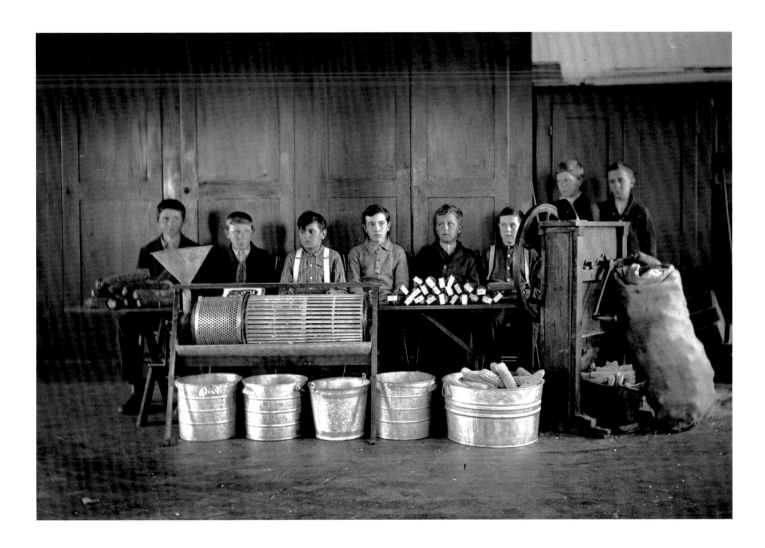

F. William Miller.
Loading the flour shipment for export by train, Amana Flour Mill, ca. 1915.
Museum of Amana History, gift of Alan and Louise Miller DuVal.

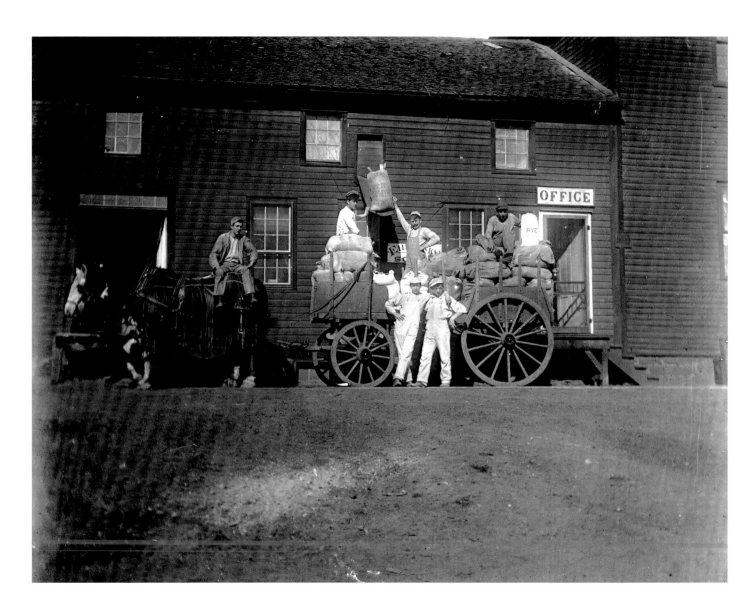

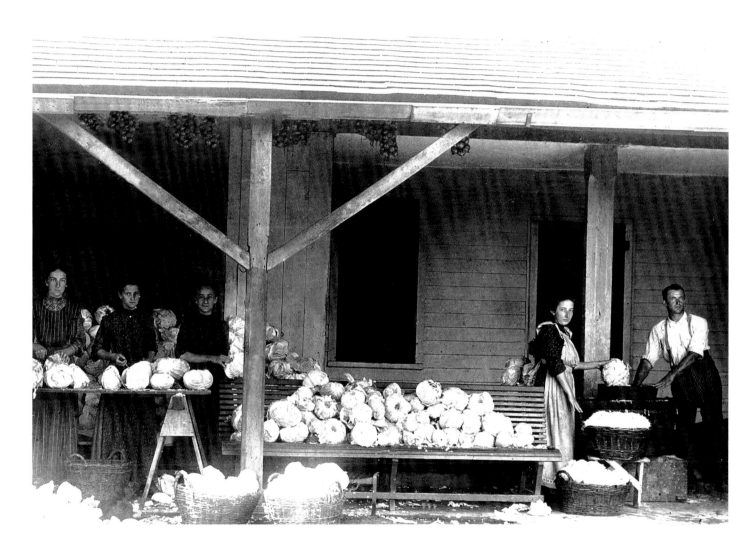

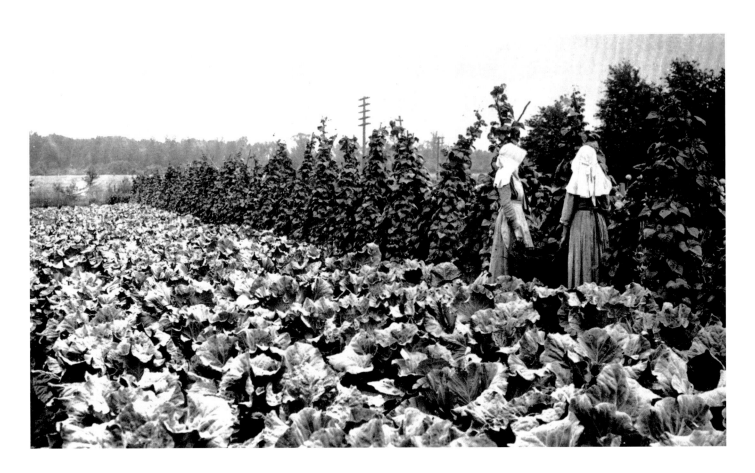

Christian Herrmann.
Cleaning the doctor's office for Dr. Christian Herrmann, Sr.,
Middle Amana, ca. 1908.
Collection of Adolph and Ruth Herrmann Schmieder.

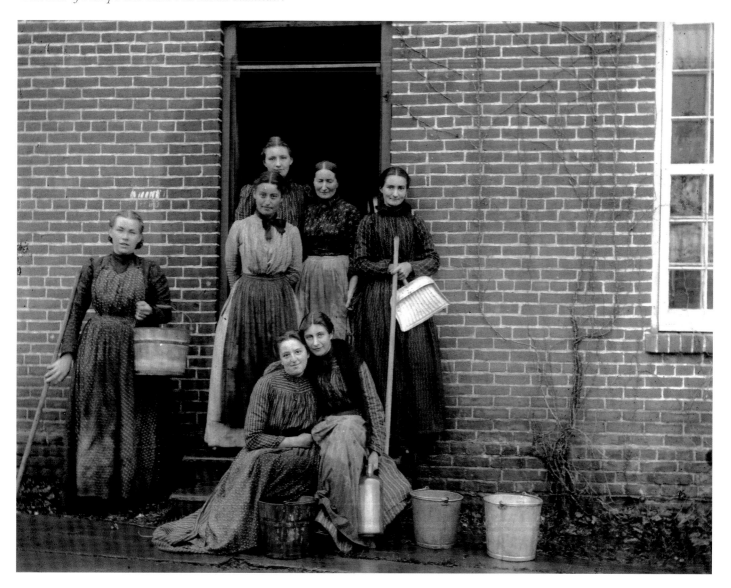

Friedrich Oehl.
"Heinz Kitchen Personnel," Amana communal kitchen, Amana, ca. 1907.
Museum of Amana History, gift of the Louise Noé family.

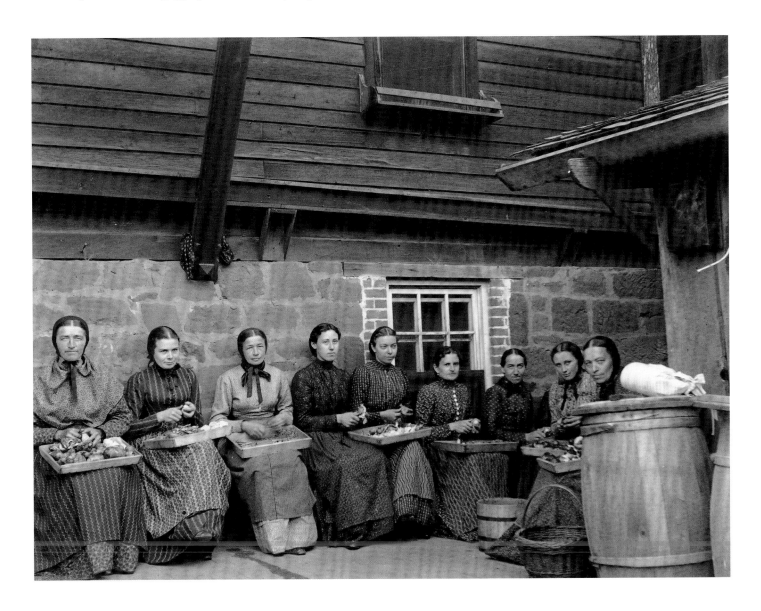

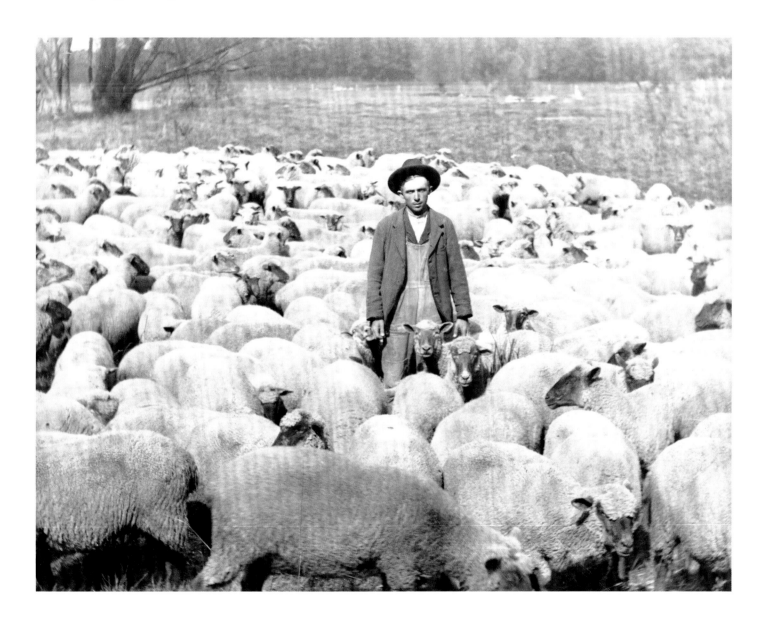

Rudolph Kellenberger.
Sawmill in Amana, 1934.
Museum of Amana History.

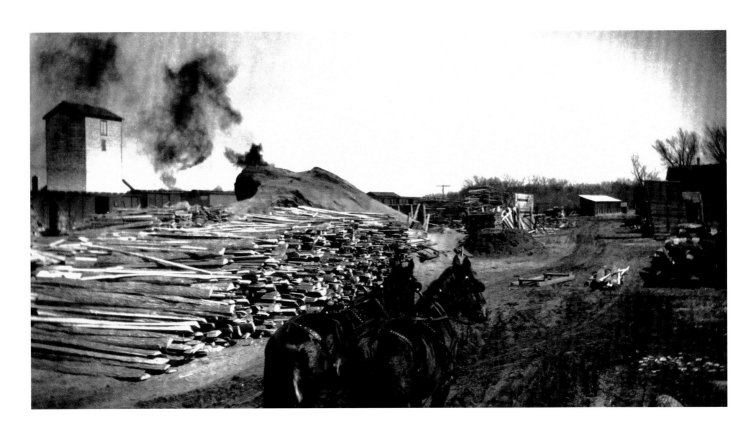

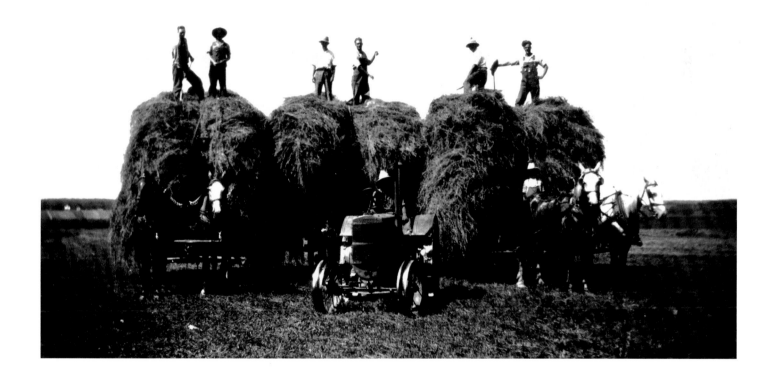

William F. Noé.
Plowing, ca. 1935.
Museum of Amana History.

William Foerstner.
Gardening in High Amana, ca. 1910.
Collection of Clifford Trumpold.

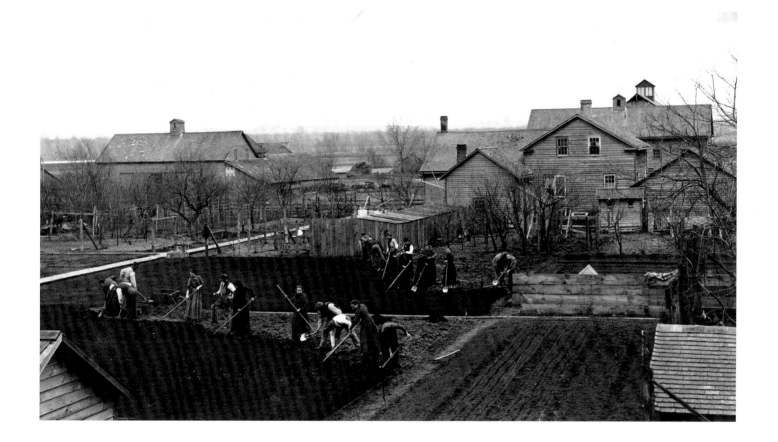

William Foerstner.
Bicyclists on the back road to High Amana, ca. 1910.
Collection of Emilie Foerstner Jeck.

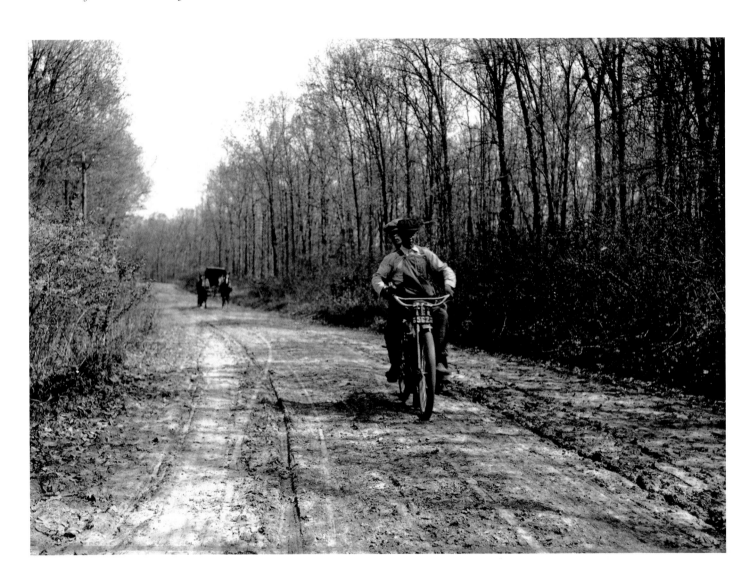

Charles Ruedy.
Boating on the Mill Race.
The six-mile canal was completed in 1867 to provide water power
for the flour mills, woolen mills and other Amana industries.
Taken at the West Bridge near Middle Amana, ca. 1908.
Collection of Clifford Trumpold.

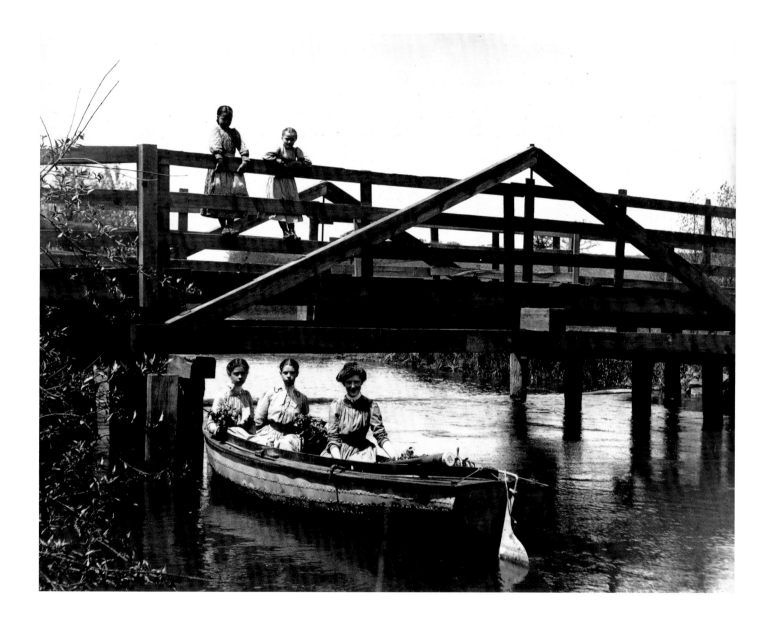

Bertha Shambaugh.
The flour mill, Amana, ca. 1890s.
Private collection.

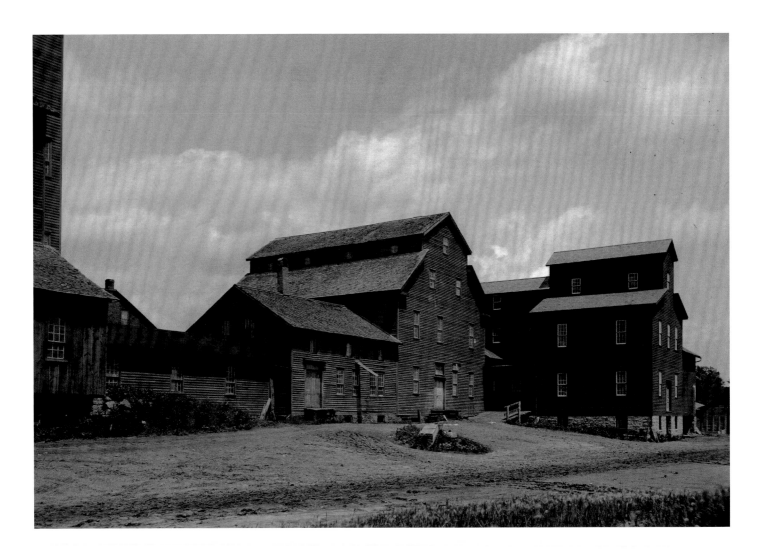

William Foerstner.
Wedding procession, August 22, 1907.
Foerstner set up his camera in an upstairs window of the
High Amana Church and had a friend trip the shutter as he and
Christina Gernand lead the procession to their wedding service.
Collection of Emilie Foerstner Jeck.

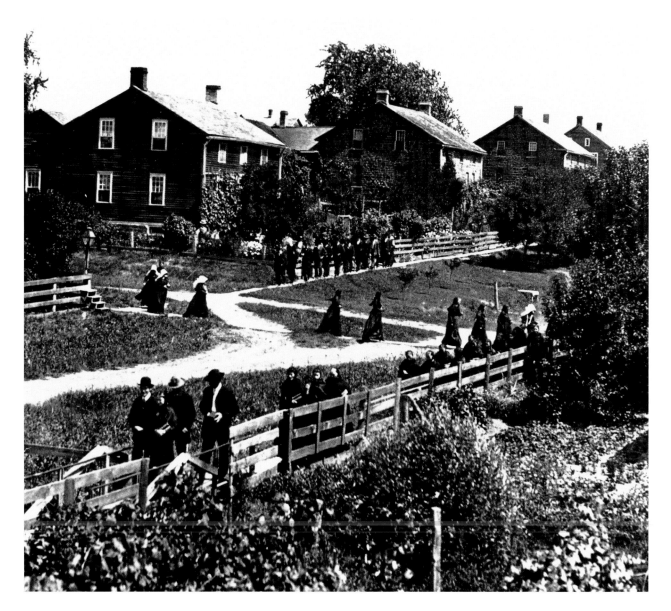

Friedrich Oehl.
Liebesmahl (communion), the most sacred Inspirationist religious service, gathered all members of the community in Amana every *other year. Oehl captured the scene from an upstairs window of the schoolhouse, now the Museum of Amana History, 1900. Museum of Amana History.*

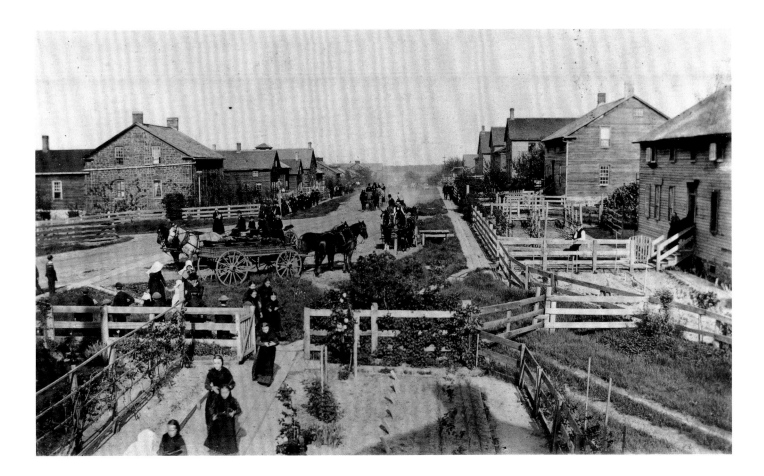

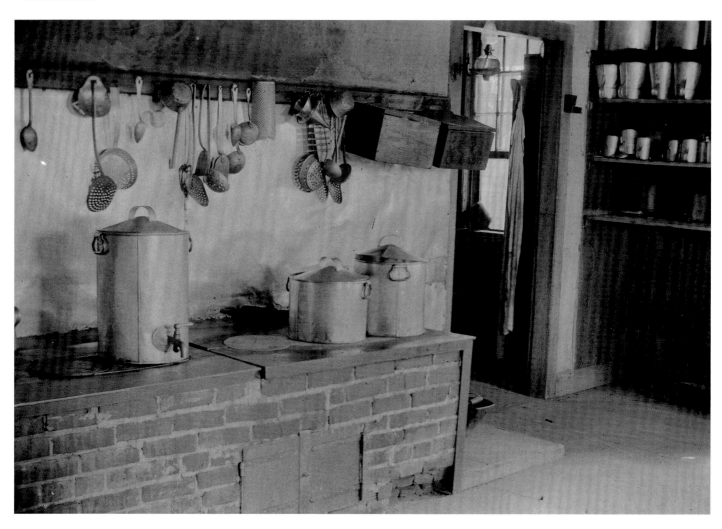

Bertha Shambaugh.
F. William Miller at his pharmacy,
Homestead, ca. 1900.
Private collection.

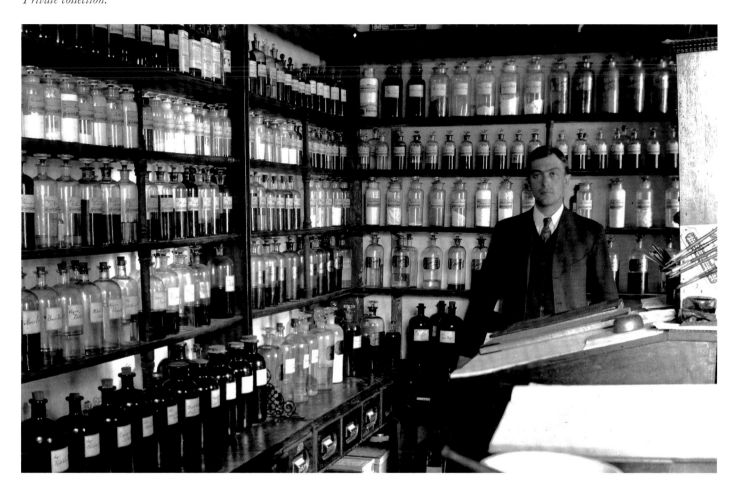

Bertha Shambaugh.
Schoolhouse, Amana, ca. 1890s.
Private collection.

William F. Noé.
Harvest wagons, Amana, 1935.
Museum of Amana History.

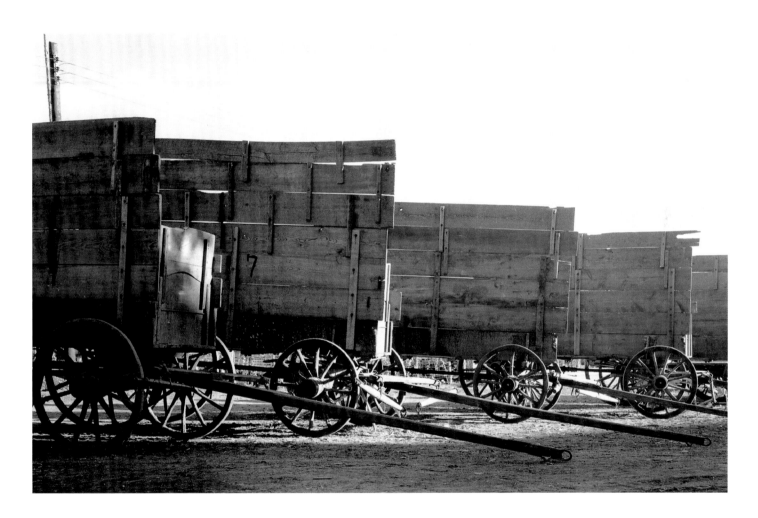

William Foerstner.
"Solid Comfort" (photographer's note on the postcard
print of this picture), High Amana, ca. 1910.
Collection of Emilie Foerstner Jeck.

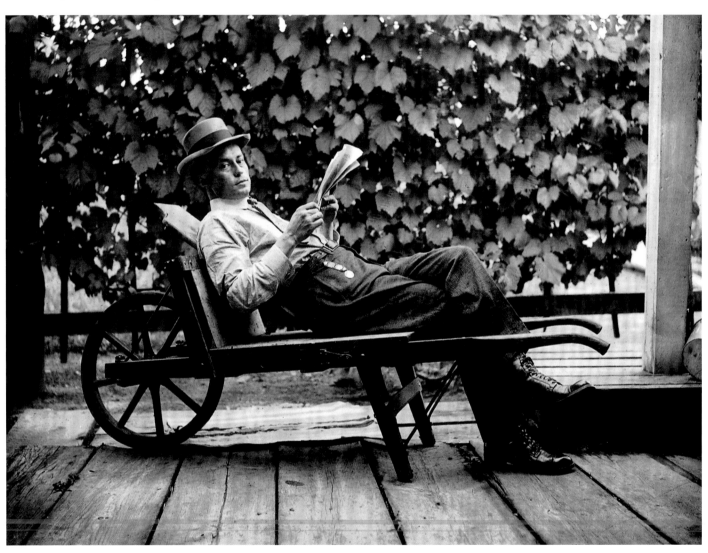

Friedrich Oehl.
"Our kids playing horses—Grandmother in the distance."
Museum of Amana History, gift of Catherine Oehl Guerra.

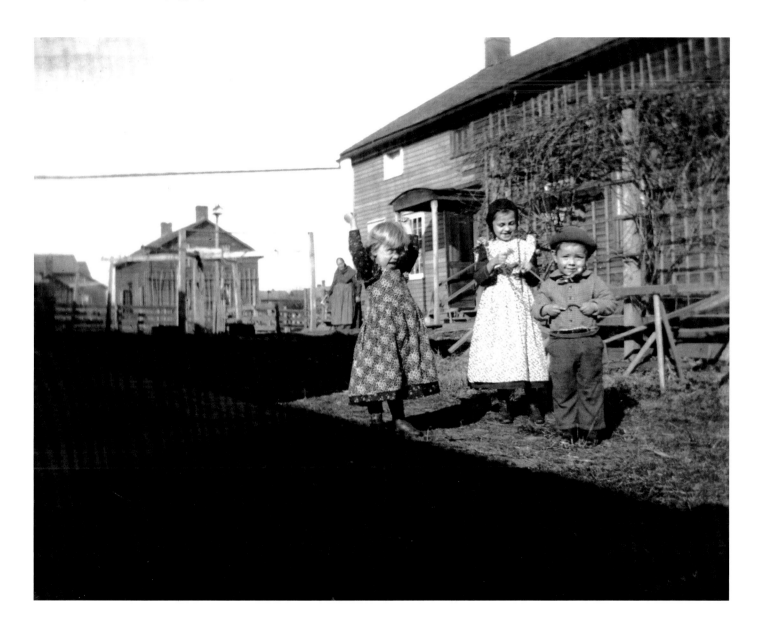

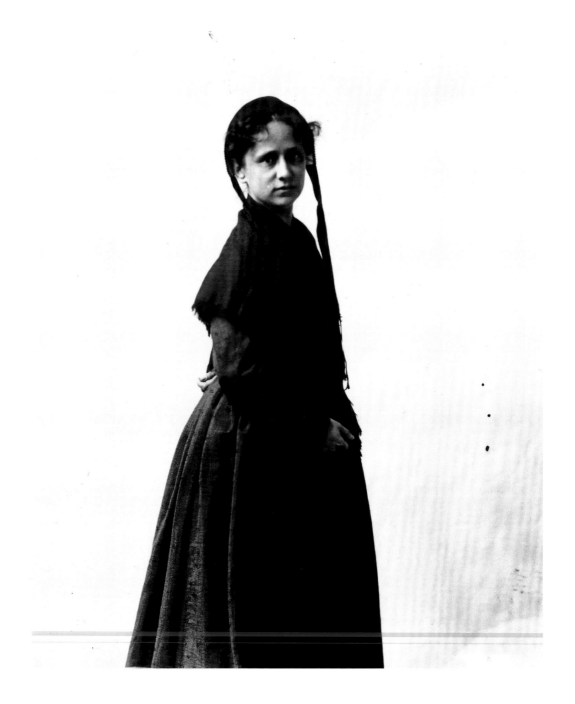

Bertha Shambaugh.
Self-portrait in Amana
dress at the time of publication
of her 1908 book, Amana:
The Community of
True Inspiration.
Shambaugh Archive, State
Historical Society of Iowa.

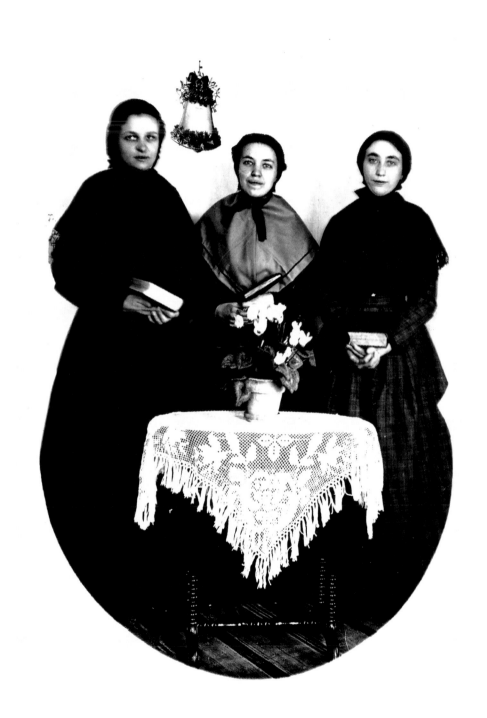

Paul Kellenberger.
West Amana artist
Carl Flick, ca. 1935.
Collection of the photographer.

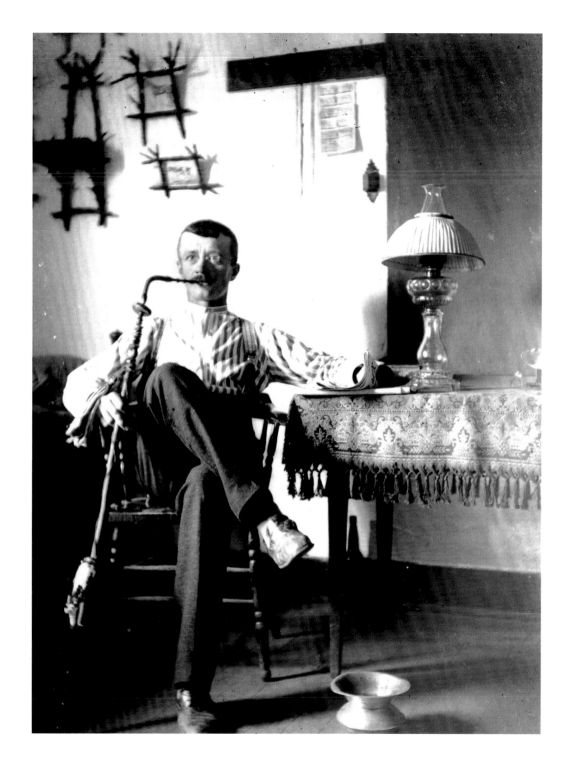

Friedrich Oehl.
"Piestengel Paul," an
itinerant worker in Amana
nicknamed for his taste for
piestengel (rhubarb) wine, 1903.
Museum of Amana history,
gift of the Louise Noé family.

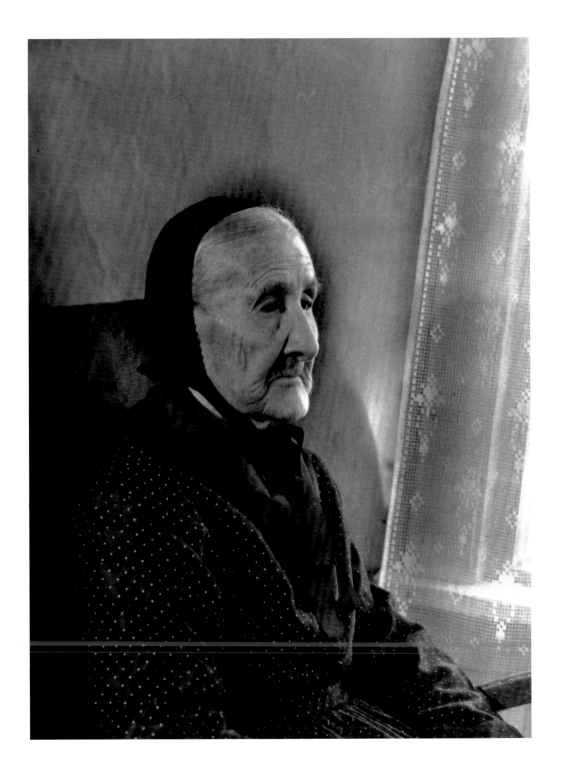

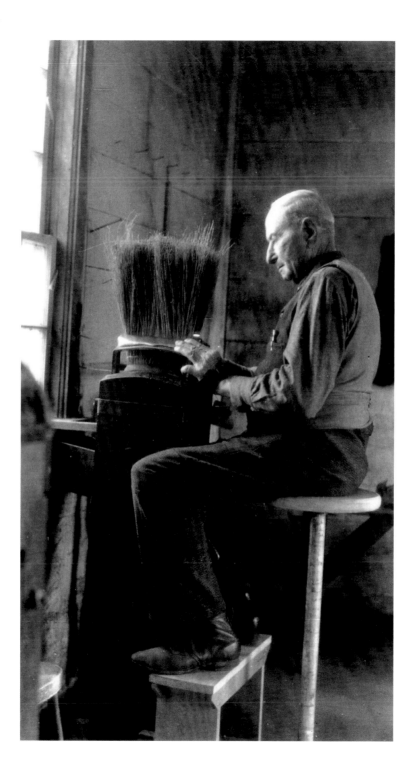

99

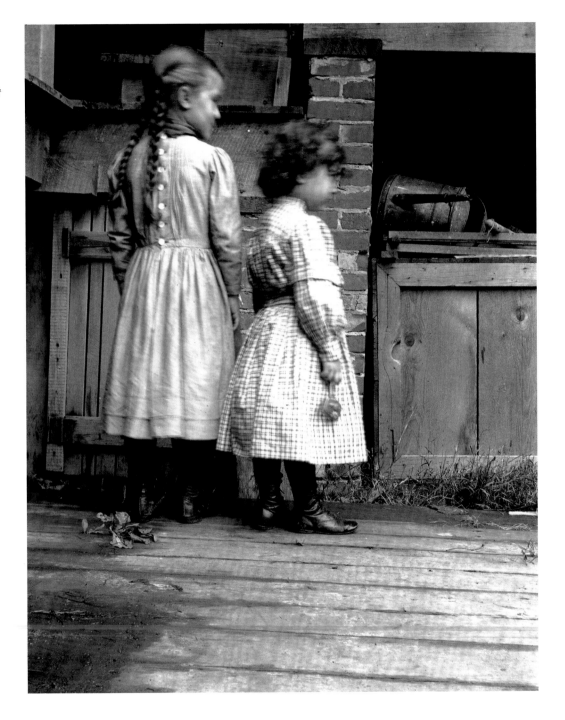

Christian Herrmann.
Girls at the communal kitchen,
Middle Amana, ca. 1910.
Museum of Amana History, gift
of Ruth Herrmann Schmieder.

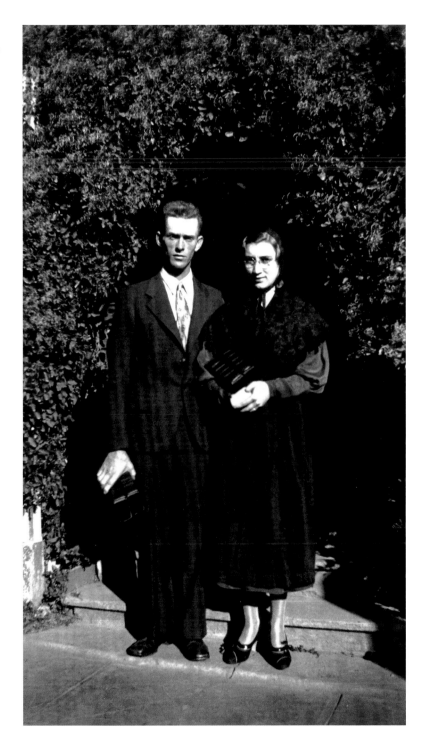

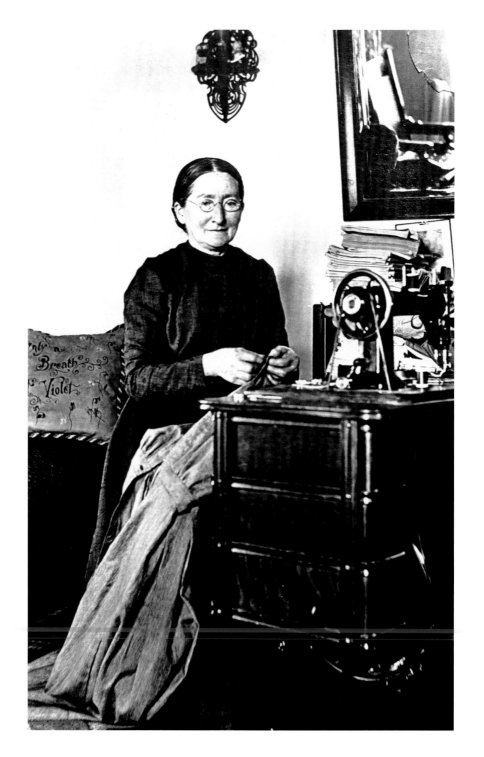

F. William Miller.
"Mother's Wheeler &
Wilson Sewing Machine,"
Miller's mother-in-law Maria
Herrmann, Amana, 1919.
Museum of Amana History,
gift of Alan and Louise Miller
DuVal.

Christian Herrmann.
"Jo at Stove," portrait of his wife Johanna Jeck Herrmann,
Middle Amana, November 13, 1919.
Museum of Amana History, gift of Ruth Herrmann Schmieder.

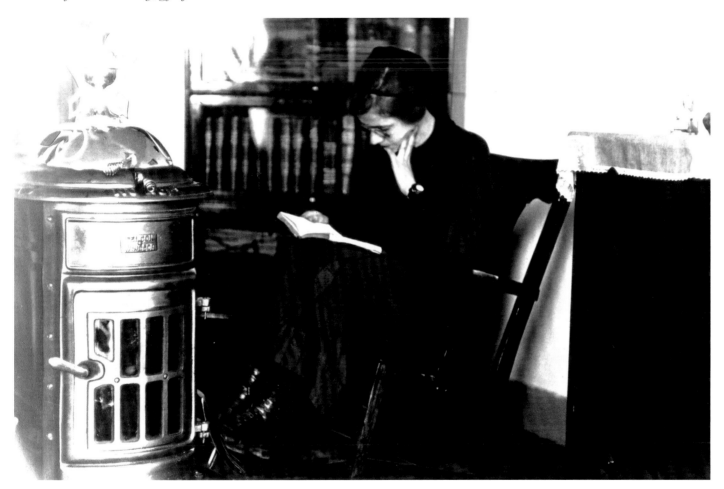

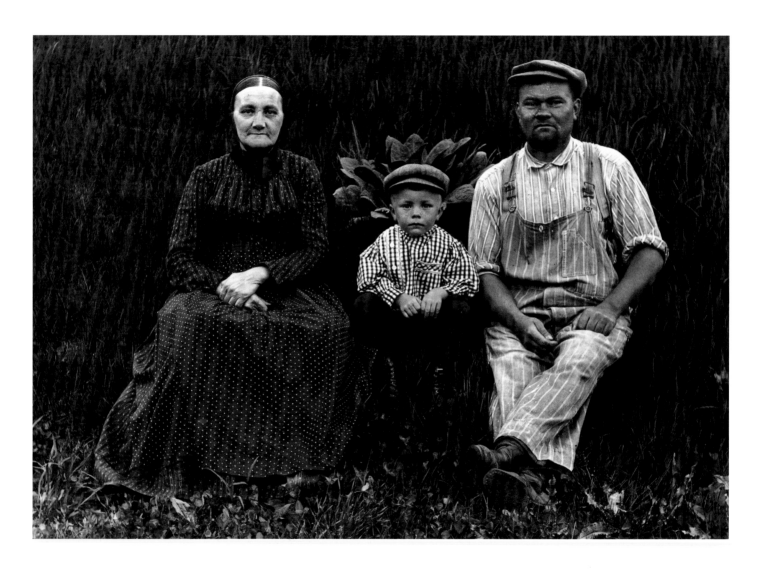

Peter Stuck.
Amana Village School, Class of 1919.
Collection of Clifford Trumpold.

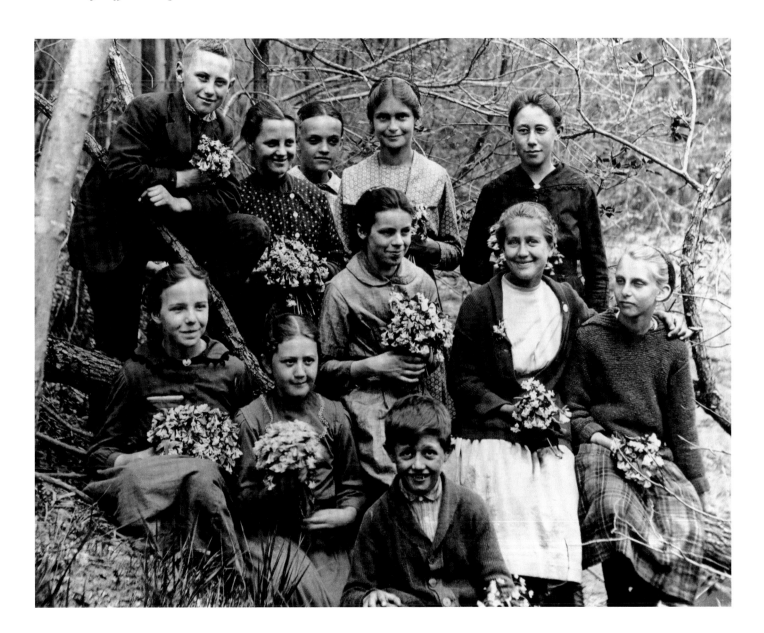

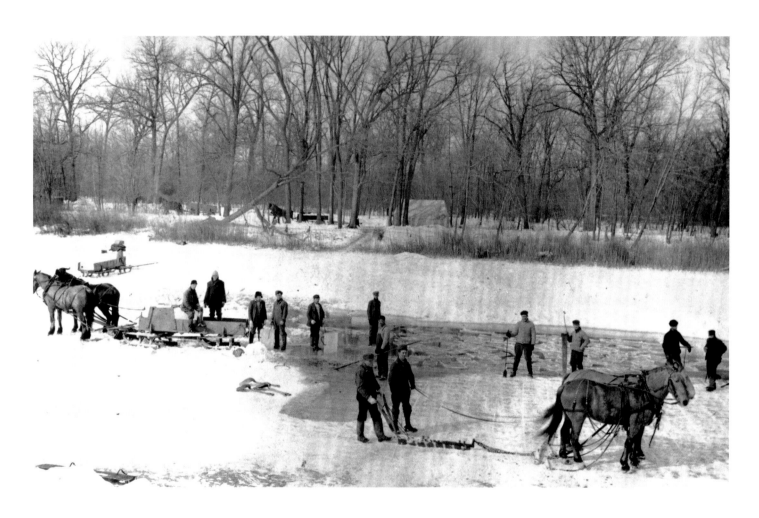

Christian Herrmann.
"A Snowstorm Won't Stop Mother," Maria Herrmann returning home
with food from the communal kitchen, Middle Amana, November 29, 1919.
Museum of Amana History, gift of Ruth Herrmann Schmieder.

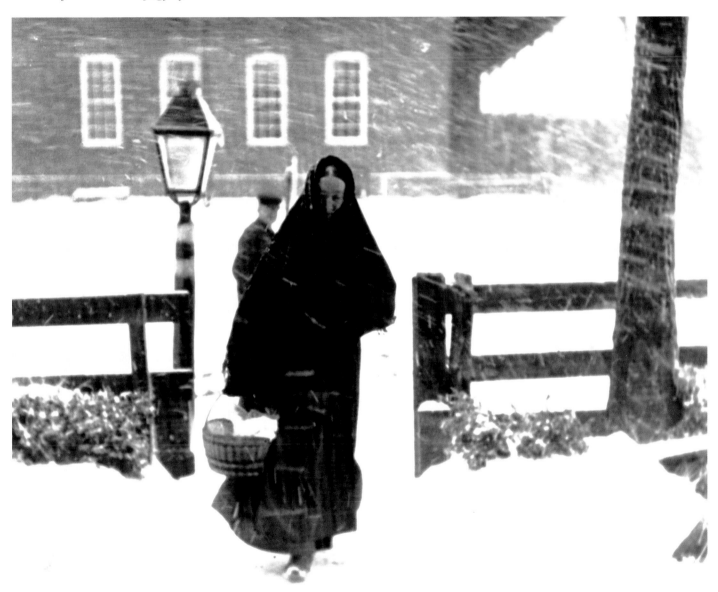

Henrietta Selzer.
Barbara Selzer Yambura, ca. 1920.
Collection of Arthur and Marie Stuck Selzer.

Friedrich Oehl.
"Load of Kids in the Sleigh," Amana, ca. 1903.
Museum of Amana History, gift of Catherine Oehl Guerra.

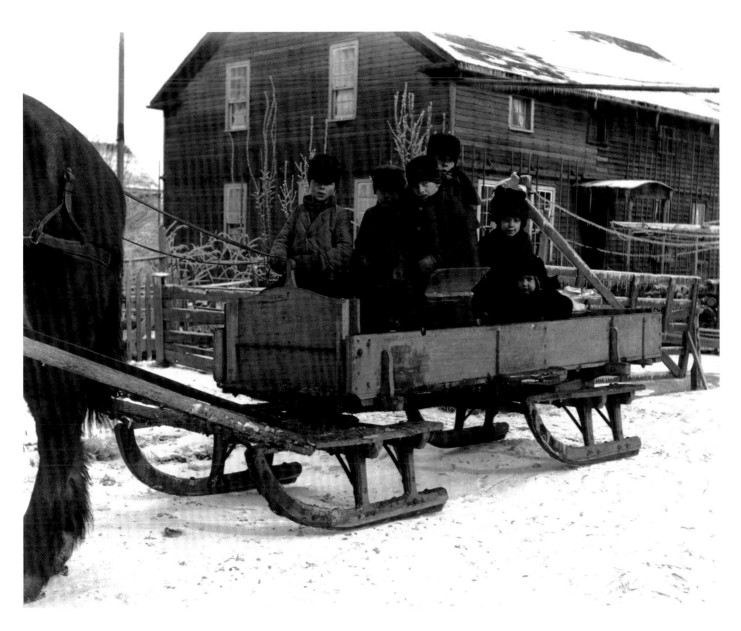

Jacob Selzer.
Cutting timber west of Homestead, ca. 1915.
Museum of Amana History.

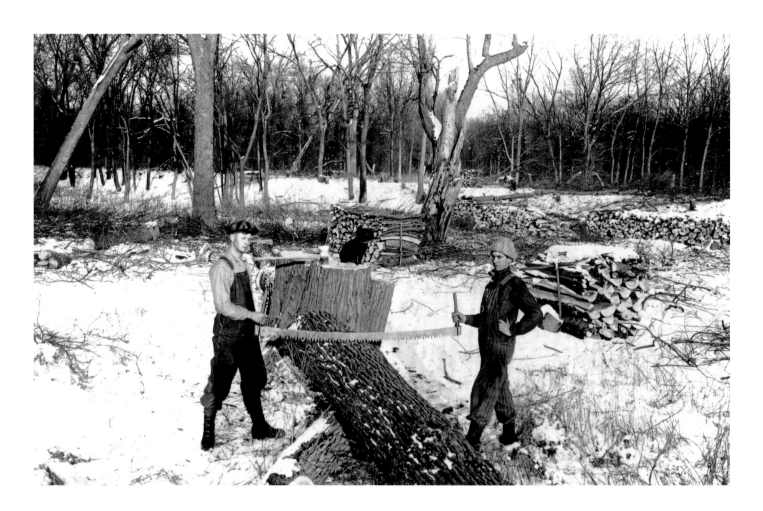

Jacob Selzer.
Spaniel posed as the great hunter. Both dog and
stump are visible in the preceding picture, ca. 1915.
Collection of Arthur and Marie Stuck Selzer.

Peter Stuck.
Seining for carp in the Amana Lily Lake, 1927.
Collection of Arthur and Marie Stuck Selzer.

F. William Miller.

"Fishing party at the old stone dam." The "Indian Dam," a rock dam laid by
Native Americans, created a fish trap on the Iowa River near Homestead, 1910.
Museum of Amana History, gift of Alan and Louise Miller DuVal.

Christian Herrmann.
Fishing near the Iowa River dam, near Homestead, ca. 1913.
Museum of Amana History, gift of Ruth Herrmann Schmieder.

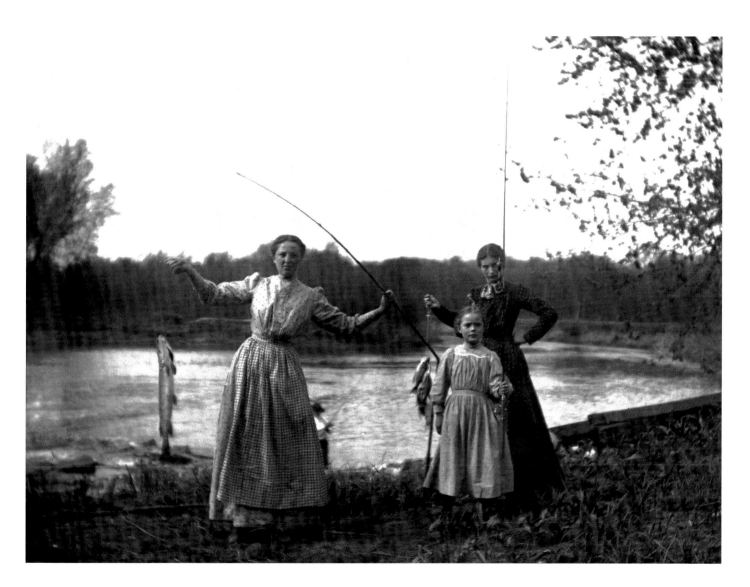

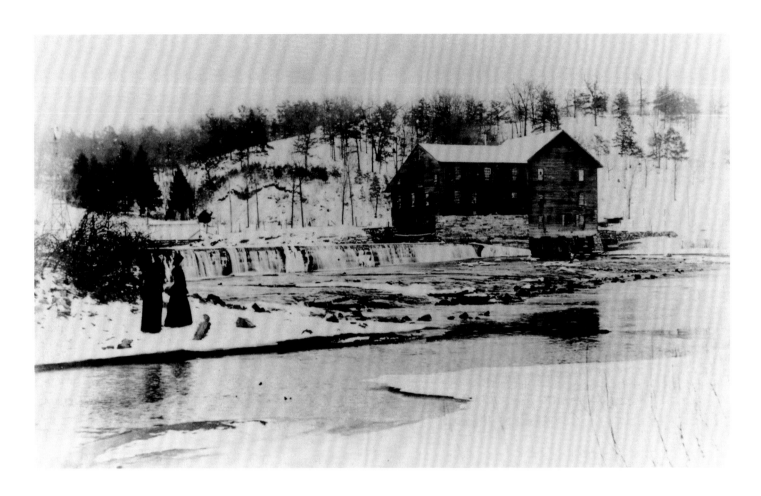

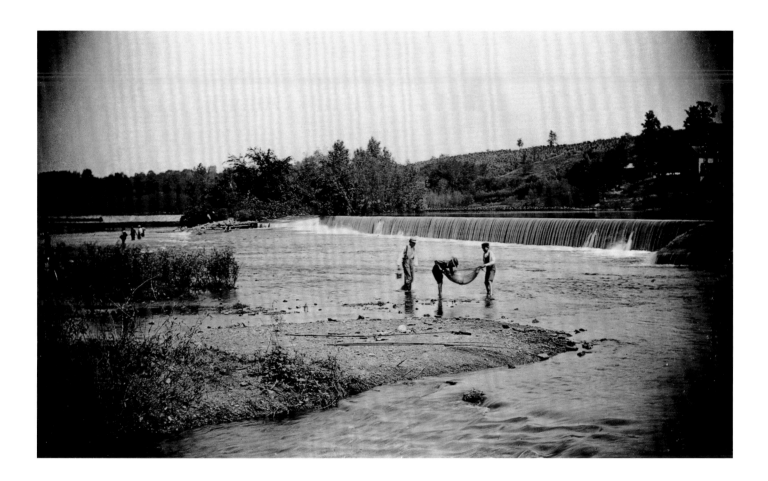

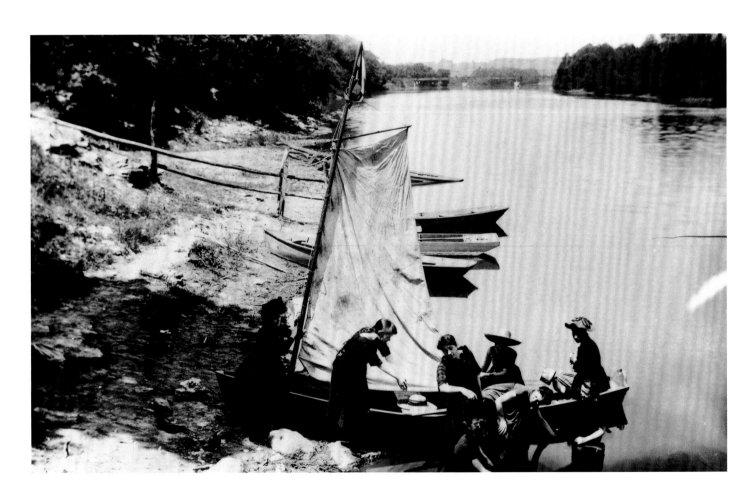

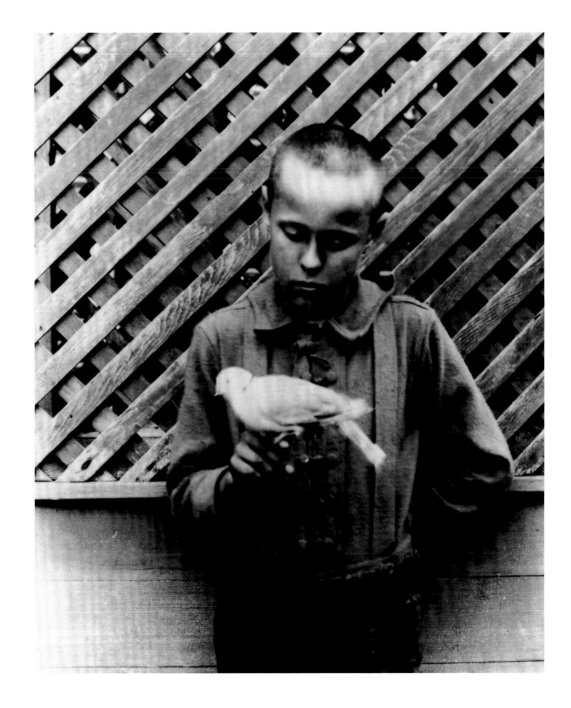

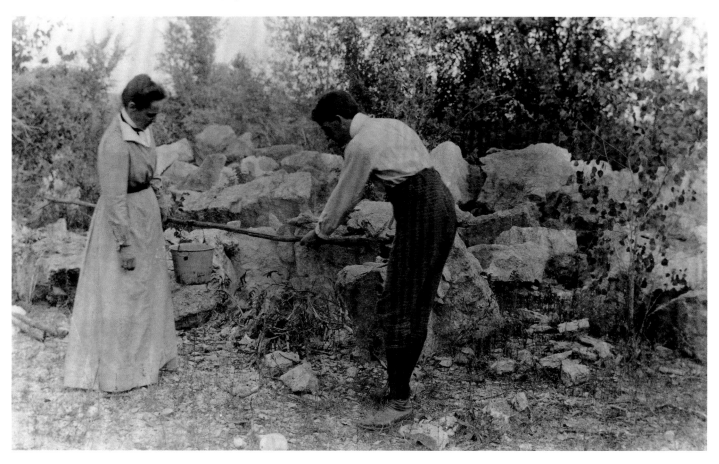

Friedrich Oehl.

"Roemig's Bicycle," portrait of relatives living in town, ca. 1903.

Museum of Amana history, gift of the Louise Noé family.

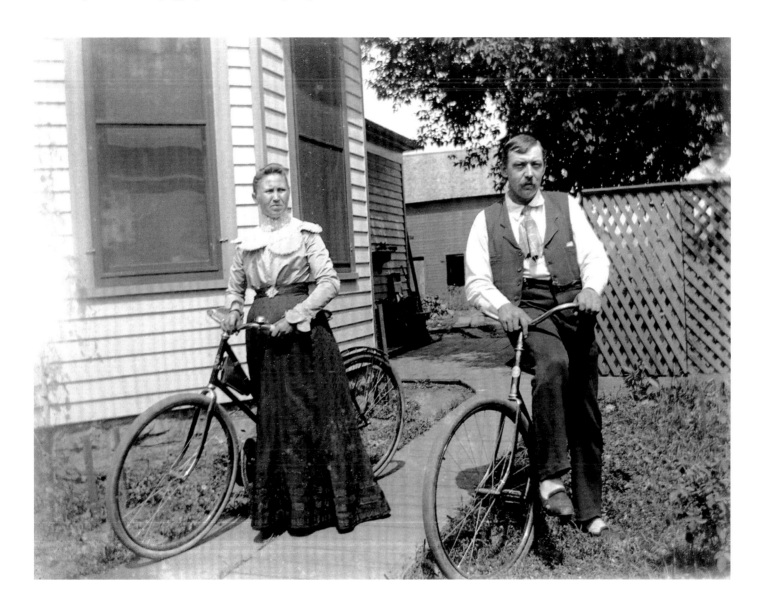

William Foerstner.
Delivery for the Brunswick Tires distributorship
at the High Amana store, ca. 1918.
Collection of Emilie Foerstner Jeck.

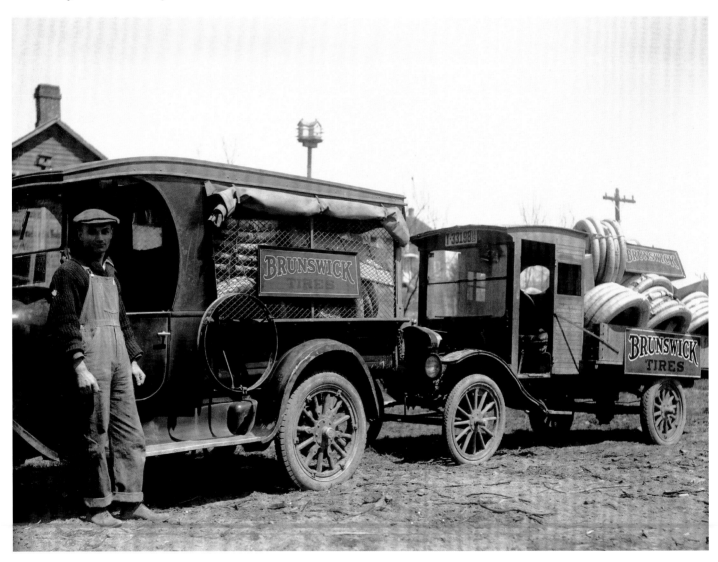

William Foerstner.
Farm children, ca. 1910.
Collection of Emilie Foerstner Jeck.

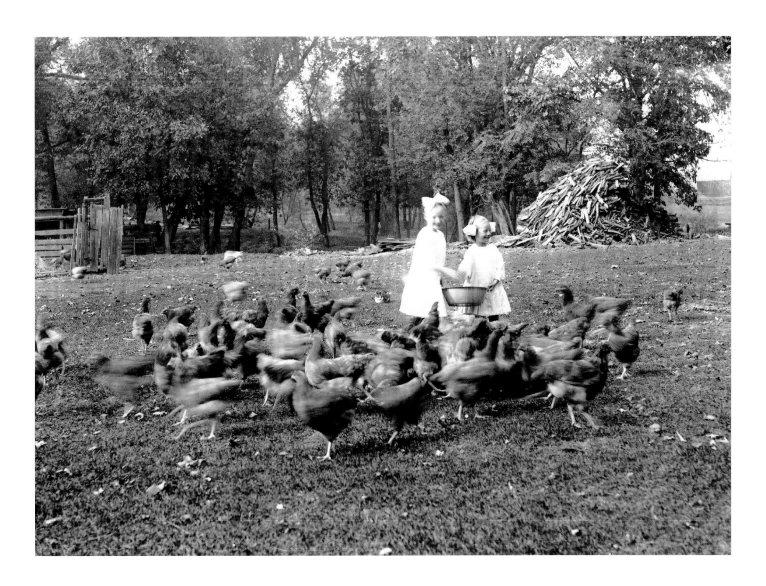

F. William Miller.
"Excursionists." The ox-drawn surrey, Amana's first tourist shuttle,
picked up passengers at the train station in Amana, ca. 1908.
Museum of Amana History, gift of Alan and Louise Miller DuVal.

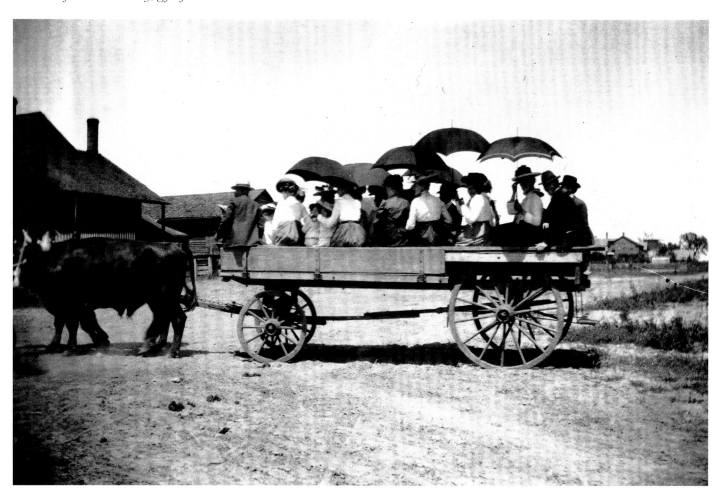

F. William Miller.
"Roadmaster John Burke at the wreck of the C.M.& St. Paul,"
freight wreck near Middle Amana, August 7, 1912.
Museum of Amana History, gift of Alan and Louise Miller DuVal.

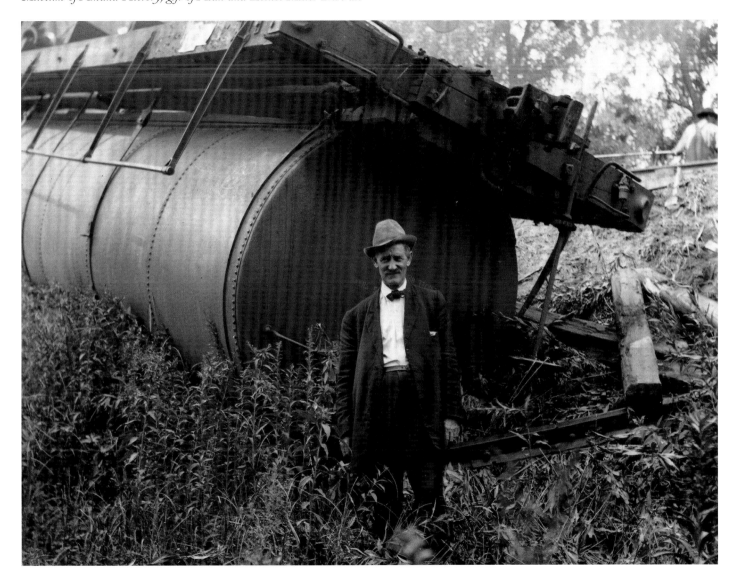

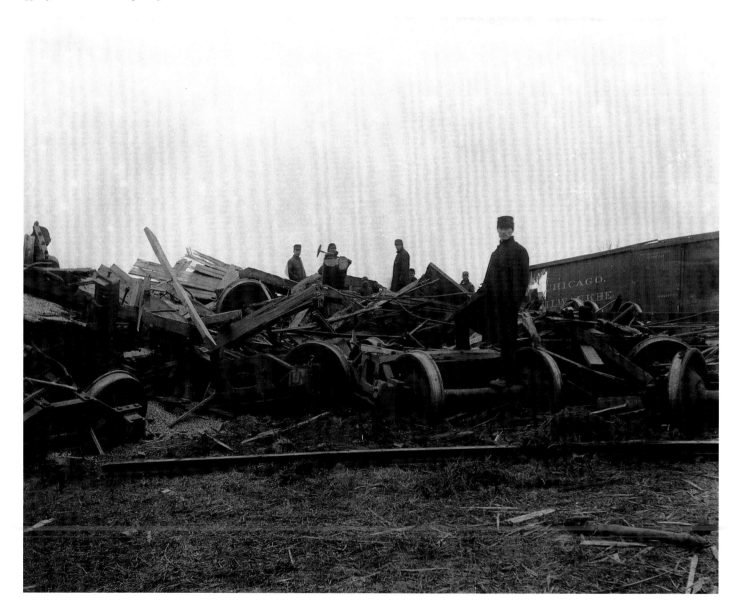

Friedrich Oehl.
"7 O'clock Snapshot," steam locomotive crossing the Iowa River, ca. 1903.
Museum of Amana history, gift of the Louise Noé family.

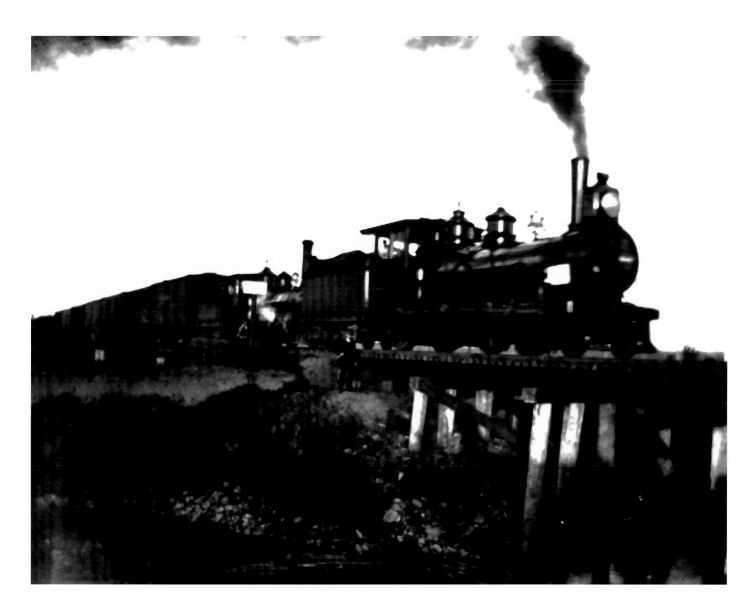

Paul Kellenberger.
Boy Scout Camp near
Iowa City, ca. 1934.
Amana boys joined the Scouts
after the Great Change.
Collection of the photographer.

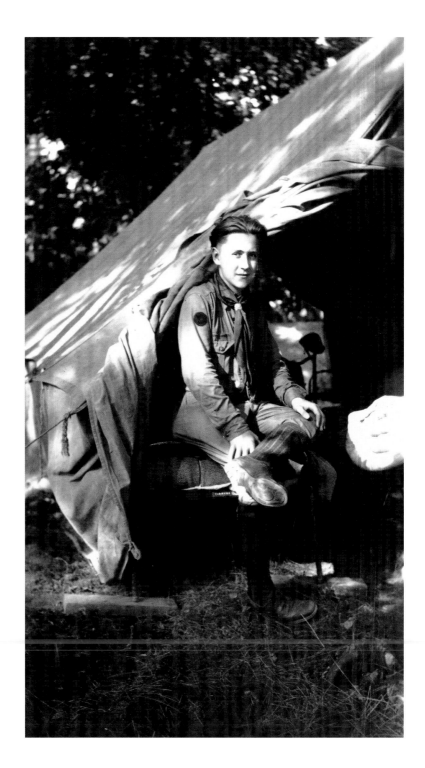

Paul Kellenberger.
The Iowa River, ca. 1935.
Collection of the photographer.

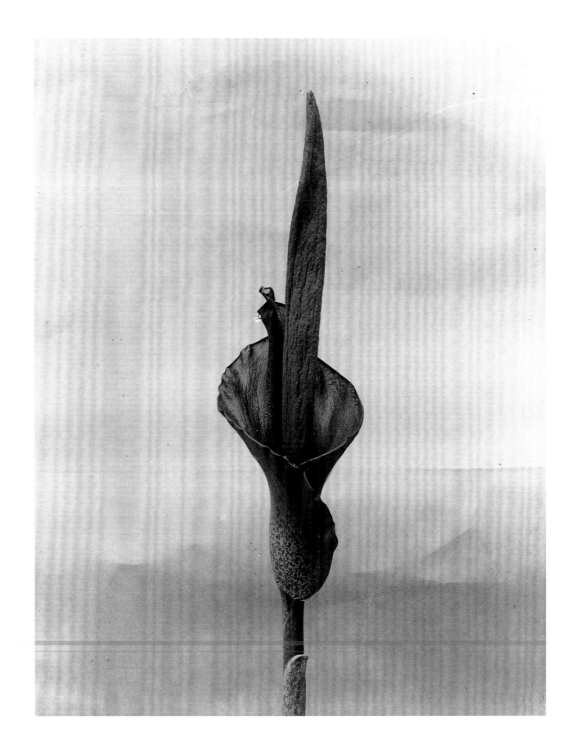

Peter Stuck.
"*Milkweed Pods Open*," 1930.
*Collection of Arthur and
Marie Stuck Selzer.*

Peter Stuck.
"Spectabilis"
(bleeding-heart), 1930.
Collection of Arthur and
Marie Stuck Selzer.

Peter Stuck.
"Milkweed Pods," 1930.
Collection of Arthur and
Marie Stuck Selzer.

Christian Herrmann.
Pellegra, August 25, 1927.
Physician Christian Herrmann's medical case studies attest to
the artistic and humanistic vision he brought to all his photographs.

He numbered many of his negatives, as shown here, and the
numbers matched those in a log giving dates, exposure times,
and descriptions of each shot.
Collection of Adolph and Ruth Herrmann Schmieder.

Christian Herrmann.
"Bill's Back," March 27, 1927.
Collection of Adolph and Ruth Herrmann Schmieder.

Christian Herrmann.
Chair used to set broken hips in the office of
Dr. Christian Herrmann, Sr., Middle Amana, 1907.
Collection of Adolph and Ruth Herrmann Schmieder.

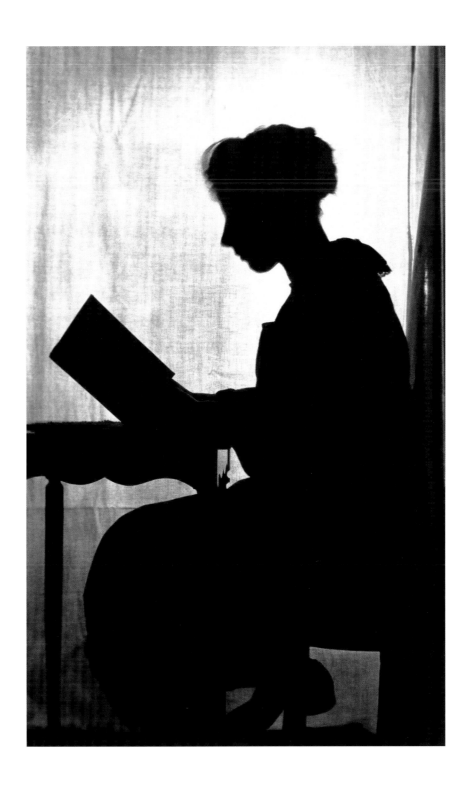

NOTES

Most of the direct quotations in the text are from interviews with the author (see interview section in the bibliography for sources). Quotations and references from other sources are cited below.

Preface

1. Bertha Shambaugh, *Amana: The Community of True Inspiration* (1908; reprint, Iowa City: Penfield Press, 1988), 143–144.
2. Joel Meyerowitz and Colin Westerbeck, *Bystander: A History of Street Photography* (New York: Little, Brown, 1994), 36.

Introduction

1. Bertha Shambaugh, background about her relationship to the Amana Colonies written in the form of questions and answers, post-1932, box 13, folder 41, Shambaugh Archive, University of Iowa Libraries.

Bertha Horack Shambaugh:
Pioneering Photographer

1. Benjamin Shambaugh, 1905 diary, Shambaugh Archive, box 38, file 8, Special Collections, University of Iowa Libraries, Iowa City.
2. Bertha Shambaugh, "The Evolution of Birds," 1888 research paper for the Agassiz Asso-

ciation, box 13, Shambaugh Archive, University of Iowa Libraries.
3. Bertha Shambaugh, scrapbook circa 1885, box 40, Shambaugh Archive, University of Iowa Libraries.
4. Receipts of Benjamin and Bertha Shambaugh, Shambaugh Archive, box 9, folder 12, State Historical Society of Iowa, Iowa City.
5. Karin Becker Ohrn, "Making Belief: Contexts for Family Photographs" (paper presented at the sixth biennial convention of the State American Studies Association, Oct. 27–30, 1977, Boston) 13.
6. Miranda Hofelt, "Camera and Corset" (lecture on nineteenth-century women photographers, presented at the Art Institute of Chicago, 1998).
7. Ibid.
8. Naomi Rosenblum, *A History of Women Photographers* (New York: Abbeville Press, 1994), 93–113.
9. Mary Bennett, *An Iowa Album: A Photographic History, 1860–1920* (Iowa City: University of Iowa Press, 1990), 315–319.
10. Railroad exhibit archive, Museum of Amana History, Amana, Iowa.

Bertha and Benjamin Shambaugh:
Hosts for a Mecca of Minds

1. Bertha Shambaugh, biographical sketch of Benjamin Shambaugh, box 35, folder 8, Shambaugh Archive, University of Iowa Libraries.

2. Memorial service and tributes to Benjamin Shambaugh, box 38, folders 11–14, Shambaugh Archive, University of Iowa Libraries.

3. Ibid.

4. Bertha Shambaugh, biographical sketch of Benjamin Shambaugh, box 35, folder 8, Shambaugh Archive, University of Iowa Libraries.

5. Marianne Fulton, *Eyes of Time, Photojournalism in America* (Boston, New York Graphic Society, 1988), 43.

6. Bertha Horack, "Amana Colony: A Glimpse of the Community of True Inspiration," *Midland Monthly* 6, no. 1 (July 1896): 30.

7. Ibid., 36.

8. W. J. Peterson, *Palimpsest* (June 1921): 229–230.

9. Horack, 35.

10. Stow Persons, *The University of Iowa in the Twentieth Century: An Institutional History* (Iowa City: University of Iowa Press, 1996), 38–40.

11. Receipts, box 1, file 13, Shambaugh Archive, University of Iowa Libraries.

12. Persons, 23.

13. Kathleen Bonann-Marshall, "This Old House," 1981 annual report, University of Iowa Foundation, celebrating the conversion of the landmark residence into the home of the university honors program.

14. *Benjamin Franklin Shambaugh: As Iowa Remembers Him, 1871–1940* (Iowa City, University of Iowa, 1941).

15. Sara Cox Rigler, interview by Mary Bennett, 1982, State Historical Society of Iowa.

16. Katherine Horack Dixon, interview by Mary Bennett, 1982, State Historical Society of Iowa.

17. Ibid.

18. Rebecca Christian, "Her Starring Role in Their Polished Show," *Iowan* (Sept. 30, 1990): 37.

19. Benjamin Shambaugh, 1905 diary.

20. Bennett, *An Iowa Album*, 112.

21. Ibid., 165.

22. Bertha Shambaugh, Biographical sketch of Benjamin Shambaugh, box 35, folder 13.

23. Benjamin Shambaugh, 1905 diary.

24. Bertha Shambaugh, *Amana: The Communtiy of True Inspiration*, p. 34.

25. Ibid., 15.

26. Bertha Shambaugh, housebook annotation, box 19, Shambaugh Archive, University of Iowa Libraries.

27. Bertha Shambaugh, correspondence, Shambaugh Archive, State Historical Society of Iowa.

28. Dixon, interview.

29. Bertha Shambaugh, "The Glory of Amana Has Not Departed," *Des Moines Register* (May 15, 1935); manuscript, box 13, folder 16, Shambaugh Archive, University of Iowa Libraries. Shambaugh's prominence as a historian earned her biographical sketches in *Who's Who in America* and *American Women* in the 1930s.

30. Bertha Shambaugh, housebooks, box 19, file 4, Shambaugh Archive, University of Iowa Libraries.

The Amana Experience

1. Bertha Shambaugh, *Amana That Was and Amana That Is* (Iowa City: State Historical Society of Iowa, 1932), 353.

2. Bertha Shambaugh, *Amana: The Communtiy of True Inspiration*, p. 22.

3. Bertha Shambaugh, *Amana: The Community of True Inspiration*, 30.

4. Ibid., 39.

5. Ibid., 40.

6. Ibid., 55.

7. Ibid., 65.

8. Abigail Foerstner, "The Amana Colonies: Evolution of a Planned Society," independent study, Northwestern University, Evanston, Ill., 1971. Assessment of reasons for the Great Change drawn from interviews with twenty-four people.

9. Stow Persons, *American Minds: A History of Ideas* (New York: Holt, Rinehart and Winston, 1958), 3–43.

10. Foerstner, "The Amana Colonies."

Amana Photographers: The Insider's View

1. George Talbot, *At Home: Domestic Life in the Post-Centennial Era, 1876–1920* (Madison: State Historical Society of Wisconsin, 1976), iv–vii, 45–50.

2. Morris Hillquit, *History of Socialism in the United States* (New York: Funk and Wagnalls, 1910), 40.

3. F. William Miller, unpublished diary 1896–1899, entry for March 9, 1897.

4. Barbara Yambura, *A Change and a Parting* (Ames: Iowa State University Press, 1960), 247–257.

BIBLIOGRAPHY

Interviews

On Amana Photographers
Clifford Trumpold, photographer, Middle Amana, June 17, 1998.

On William Foerstner
Emilie Foerstner Jeck, daughter, High Amana, November 20, 1997; February 26, 1998.
George Foerstner, son, Middle Amana, May 9, 1998.
Joann Foerstner Meyer, granddaughter, Middle Amana, May 9, 1998.

On Christian Herrmann
Ruth Herrmann Schmieder, daughter, Middle Amana, December 19, 1997.

On Paul and Rudolph Kellenberger
Paul Kellenberger, brother of Rudolph and the only surviving photographer of those featured in this book, Norridge, Ill., February 19, 1998.
Patrick Kellenberger, nephew, and his wife, Kathy Kellenberger, Middle Amana, November 19, 1997.
Erma Schanz Kellenberger, widow of Rudolph, West Amana, November 20, 1997.

On F. William Miller
Louise Miller DuVal, daughter, Mount Vernon, Iowa, July 29, 1997; January 28, 1998; February 27, 1998.

On William F. Noé
Marie Noé Larew, daughter, Kimberly City, Mo., June 27, 1998.
Emilie Hoppe, step-granddaughter, West Amana, May 9, 1998.

On Friedrich Oehl
Elizabeth Wetjen, daughter, Middle Amana, June 17, 1998.
Carl Oehl, grandson, Amana, November 19, 1997.
Catherine Guerra, great-granddaughter, Middle Amana, October 2, 1997; June 17, 1998.

On Jacob and Henrietta Selzer
Barbara Yambura, daughter, Colorado Springs, Colorado, May 21, 1998.
Arthur Selzer, nephew, Homestead, January 29, 1998.
Barbara Hoehnle, grandniece, Homestead, October 10, 1997.
Peter Hoehnle, great-grandnephew, Homestead, February 26, 1998.

On Bertha Shambaugh
Louise Miller DuVal, friend of Shambaugh and daughter of F. William Miller, Mount Vernon, July 29, 1997; January 28, 1998; February 27, 1998.
Mary Bennett, special collections coordinator, State Historical Society of Iowa, Iowa City, December 18, 1997.

On Peter Stuck

　　Art Selzer, son-in-law, Homestead, January 29, 1998.

　　Barbara Hoehnle, granddaughter, Homestead, October 10, 1997.

　　Peter Hoehnle, great-grandson, Homestead, February 26, 1998.

General Sources

　　Mary Bennett, special collections coordinator, State Historical Society of Iowa, Iowa City.

　　Lanny Haldy, director, Museum of Amana History, Amana.

　　Catherine Guerra, collections curator, Museum of Amana History, Amana.

　　Clifford Trumpold, photographer and photo collector, Middle Amana.

　　Stow Persons, professor emeritus of history, University of Iowa.

Archives and Publications

University of Iowa Libraries, Special Collections, Iowa City. Forty-eight boxes of papers, diaries, and photographs.

State Historical Society of Iowa, Iowa City, Shambaugh Collection. Archive of papers, photographs, glass plate negatives and lantern slides.

Museum of Amana History (operated by the Amana Heritage Society), Amana, Iowa. Extensive collections on Amana History. Collection of thousands of prints and numerous glass plate and film negatives.

Books on Amana and Iowa

Amana Church Society. *Cathecism*. Amana, Iowa: Amana Church Society, 1968.

Andreas, A. T. *Illustrated Historical Atlas of the State of Iowa*. 1875. Chicago: Andreas Atlas Co., 1875.

Barthel, Diane L. *Amana: From Pietist Sect to Modern Community*. Lincoln: University of Nebraska Press, 1984.

Bourret, Joan Liffring-Zug, comp. *Life in Amana 1867–1935, Reporters' Views of the Communal Way*. Iowa City: Penfield Press, 1998.

Christen, Wallace C. *Inspirationist Mysticism and the Amana Community*. Lockport, Ill.: Ogden Press, 1975.

DuVal, Francis Alan. "Christian Metz, German-American Religious Leader and Pioneer." Ph.D. diss., University of Iowa, 1948.

Gerber, John C. *A Pictorial History of the University of Iowa*, Iowa City: University of Iowa Press, 1988.

Hillery, George. *Communal Organizations: A Study of Local Societies*. Chicago: University of Chicago Press, 1968.

Liffring-Zug, Joan. *The Amanas Yesterday*. Iowa City: Penfield Press, 1975.

―――. *Seven Amana Villages*. Iowa City: Penfield Press, 1981.

Metz, Christian. *A Revelation of Jesus Christ through the Spirit of True Inspiration to the President of the United States, to the Senate, and House of Representatives now assembled in the City of Washington, D.C., and to the Governors of the States of the Union*. Amana, Iowa: Amana Society, 1860 or 1861.

Noé, Charles F. *A Brief History of the Amana Society*. Amana, Iowa: Amana Society, 1901.

Persons, Stow. *The University of Iowa in the Twentieth Century.* Iowa City: University of Iowa Press, 1990.

Ruff, Henrietta. *Seasons to Remember: Recollections of an Amana Childhood.* Deep River, Iowa: Brennan Printing, 1996.

Scheuner, Gottlieb. *Inspirations—Historie, 1714–1923.* 10 vols. Amana, Iowa: Amana Society, 1884–1923.

Shambaugh, Bertha. *Amana: The Community of True Inspiration.* Iowa City: State Historical Society of Iowa, 1908, reprint, Iowa City, Penfield Press, 1988.

———. *Amana That Was and Amana That Is.* Iowa City: State Historical Society of Iowa, 1932.

Yambura, Barbara. *A Change and a Parting.* Ames: Iowa State University Press, 1960.

Books of Social History

Andrews, Faith, and Edward Andrews. *Work and Worship: The Economic Order of the Shakers.* Greenwich, Conn.: New York Graphic Society, 1974.

Francis, Richard. *Transcendental Utopias—Individual and Community at Brook Farm, Fruitlands and Walden.* Ithaca: Cornell University Press, 1897.

Hillquit, Morris. *History of Socialism in the United States.* New York: Funk and Wagnalls, 1910.

Jeffrey, Julie Roy. *Frontier Women: Civilizing the West, 1840–1880.* 1979. Reprint, New York: Hill and Wang, 1998.

Mannheim, Karl. *Ideology and Utopia.* New York: Harcourt, Brace and World, 1970.

Morse, Flo. *The Shakers and the World's People.* New York: Dodd, Mead, 1980.

Persons, Stow. *American Minds: A History of Ideas.* New York: Holt, Rinehart and Winston.

———. *Free Religion, an American Faith.* Boston: Beacon Press, 1963.

Pitzer, Donald, ed. *America's Communal Utopias.* Chapel Hill: University of North Carolina Press, 1997.

Books on Photography

Bennett, Mary. *An Iowa Album: A Photographic History, 1860–1920.* Iowa City: University of Iowa Press, 1990.

Bennett, Mary, and Paul Juhl. *Iowa Stereographs.* Iowa City: University of Iowa Press, 1997.

Davidov, Judith Fryer. *Women's Camera Work.* Durham, N.C.: Duke University Press, 1997.

Fulton, Marianne. *Eyes of Time, Photojournalism in America.* Boston: New York Graphic Society, 1988.

Greenough, Sarah, et al. *On the Art of Fixing a Shadow.* Washington, D.C.: National Gallery of Art in conjunction with the Art Institute of Chicago, 1989.

Meyerowitz, Joel, and Colin Westerbeck. *Bystander: A History of Street Photography.* New York: Little, Brown, 1994.

Moholy, Lucia. *100 Years of Photography, 1839–1939.* Hammondsworth, Middlesex: Penguin, 1939.

Newhall, Beaumont. *The History of Photography from 1839 to the Present.* New York: Museum of Modern Art, 1982.

Rosenblum, Naomi. *A History of Women Photographers.* New York: Abbeville Press, 1994.

Sandweiss, Martha. *Photography: Nineteenth Century America.* New York: Harry N. Abrams, 1991.

Szarkowski, John. *Photography Until Now.*
New York: Museum of Modern Art, 1989.

Talbot, George. *At Home: Domestic Life in the
Post-Centennial Era 1876–1920.* Madison: State
Historical Society of Wisconsin, 1976.

Thomas, Alan. *Time in a Frame: Photography and the
Nineteenth-Century Mind.* New York: Schocken
Books, 1977.

Welling, William. *Photography in America:
The Formative Years 1839–1900.* New York:
Crowell, 1978.

Wolf, Sylvia. *Julia Margaret Cameron's Women.*
New Haven: Yale University Press, 1998.

OTHER

BUR OAK

BOOKS OF

INTEREST

Birds of an Iowa Dooryard
By Althea R. Sherman
Driving the Body Back
By Mary Swander
The Folks
By Ruth Suckow
Gardening in Iowa and
Surrounding Areas
By Veronica Lorson Fowler
An Iowa Album: A
Photographic History,
1860–1920
By Mary Bennett
Iowa Birdlife
By Gladys Black
Iowa's Archaeological Past
By Lynn M. Alex

Iowa Stereographs:
Three-Dimensional Visions
of the Past
*By Mary Bennett and
Paul C. Juhl*
Neighboring on the Air:
Cooking with the KMA Radio
Homemakers
By Evelyn Birkby
Nothing to Do but Stay:
My Pioneer Mother
By Carrie Young
Prairie Cooks: Glorified Rice,
Three-Day Buns, and Other
Reminiscences
*By Carrie Young with
Felicia Young*

A Ruth Suckow Omnibus
By Ruth Suckow
Sarah's Seasons: An Amish
Diary and Conversation
By Martha Moore Davis
State Fair
By Phil Stong
The Tattooed Countess
By Carl Van Vechten
Vandemark's Folly
By Herbert Quick
Weathering Winter:
A Gardener's Daybook
By Carl H. Klaus
The Wedding Dress: Stories
from the Dakota Plains
By Carrie Young